1981

THE ARTS OF TWENTIETH CENTURY AMERICA

By
William R. Klink

University Press
of America™

Copyright © 1980 by

University Press of America, Inc.™

4720 Boston Way, Lanham, MD 20801

ISBN: 0-8191-1133-3

Library of Congress Number: 80-1423

Acknowledgements

I would like to thank Josephine Williams, Roger Horn, Russell Wapenski, Marianne Klink, and Gloria Colburn for their help and advice during the preparation of the manuscript of this book. And particular acknowledgement to George R. Cannon for his work in composing the final manuscript.

TABLE OF CONTENTS

ACKNOWLEDGEMENTS

INTRODUCTION

This book deals with a succession of visual and performing arts in America during the period of the twentieth century. It includes material on art, sculpture, architecture, drama, musical theater, music (both popular and orchestral) dance, and film. Each chapter discusses important artists and their works and marks historically important points in the development of each particular art form.

A book with the broad scope of this one is extremely difficult to control. At all points material may be added or subtracted -- a given artist or a given work given a more thorough discussion. Indeed, the temptation to revise is everpresent. In the process of selecting material for inclusion, however, I have tried to maintain the objective of writing a book that would be descriptive of twentieth century American arts, that would give the reader a general idea and some specific detail of each of the arts, and thus their development, in a manageable volume. The result is a book that is neither a bare outline of only the big events in any particular phase of the history of these arts, nor is it an encyclopedia of names, titles, and dates. I have instead strived for a middle ground, treating the broad movements with what I consider to be ample description of specific selected works.

Any book on the visual and performing arts begs for illustrations of the works cited in the text. This one does not contain them because the prohibitive cost of accurate reproduction, particularly of the abstract expressionist art which demands an accurate rendering of the original color, would drive the price of this volume far above affordability. Since this book is meant to be an introduction to the arts, money is better saved here to be spent on materials in which the reader develops a deep and abiding interest.

It would be nice, and facile, to say that each of the arts inherently lends itself to a description of its development in twentieth century America. It would also be easy if there were a direct, distinct, and consistent relationship between different art forms as they developed. Unfortunately I can find no such useful thesis which can be demonstrated. There is what I consider to be a valid thesis, however, why there can be no unifying thesis. That is, in all these forms, the artists strived for the individuality of their own private visions. When they resorted to tradition for models, sources, and inspiration, these models were subsumed, almost swallowed whole, within their individualistic temperments.

Psychologists mark the twentieth century as the age of the individual, sociologists as the age of indulgence and hedonism. These artists are sensitive reflectors of that society, their work driven to individualism through new visions of the relationships of form and content. When tradition inevitably comes to be used in the arts of the twentieth century, it is treated ironically, even disdainfully until the late seventies. And, it seems, that when this happens, and tradition becomes an accepted mode, the art form itself reaches maturity, but stops growing. This sort of development took place in rock 'n' roll music, most notably, but also, although to lesser extent, in the other forms. Fortunately for our culture, another direction is then found, another artist or group discovers a new way of presenting their individuality; life is restored, and development continues. With rock, this occurred lately with the first ill-received New Wave, Punk Rock groups, who rose to ill-fated prominence during a period of retrenchment in style marked by remakes of "old" songs. Groups immediately following these raw talents, such as Blondie, refined their techniques and set rock off again, alive and well.

But the development does not come in steady
and regular intervals. There are periods of
frenetic advances, periods of retrenchment, and
then, usually, a period of extended exuberance.
Then another direction is found, and the process
is repeated. Probably the best example of this
phenomenon is painting. The New York Armory
Show of 1918 set off a wave of abstractionism
following a period marked by conservative
representationalism. Later artists, such as
Clyfford Still, took abstract expressionism to a
refined stage. Then parodies of these earlier
visions were used to drive the work of Jasper
Johns and Robert Rauschenberg to popularity. In
turn, this style was followed by a kind of
neo-realism which relied on abstractionist tech-
niques to generate representational subject
matter.

I have chosen to place little stress on the
hundreds and thousands of social, political, and
economic events during this century which drew
all manner of artistic responses. Instead, I
have left American history in the background of
the discussions in order to place emphasis on
the arts themselves. While the arts provide a
window to the so-called real world, and con-
versely the real world to the art world,
prolonged discussions of the relationship of the
two is beyond the scope and intentions of this
book. And, in any event, it is matter ripe for
the individual speculation of the readers of
this volume.

Finally, two terms are used quite frequently
throughout the book--realism and expressionism.
To many, realism and expressionism have defini-
tions peculiar to the study of each of the
separate art forms. For the sake of simplicity,
I have used these terms throughout the book with
a mind to their broad meaning. That is, realism
is the generally objective treatment of external
reality. Expressionism is the subjective treat-
ment of internal reality. Expressionism is the

subjective treatment of personal emotion.
Realism tends toward the re-creation of ob-
servable and sensible things. Expressionism
tends toward the transposition to observable
modes unseen psychological phenomena. In
theater, expressionism manifests itself as eerie
lighting, non-sequential and non-logical dia-
logue and action, and misproportioned sets,
among other techniques. In painting, it
manifests itself as geometric shapes in
asymmetrical balance or simply, and more
usually, as lines, color, and shapes with less
regard to representing a known physical item
than with recognition of the value of the line,
color or shape itself. With many of the forms
their earlier years saw these two as mutually
exclusive, and only later as inherently comple-
mentary.

CHAPTER I

DANCE

AN OVERVIEW OF DANCE

The subject matter of dance is bodies and shapes in space. In this respect, dance has similarities to sculpture, which is also concerned with shapes in space. Dance has subject matter, a subject matter to which a narrative structure is often subordinated. It has a serial character, in its presentation of a succession of space through time. Therefore, one prerequisite for a thorough enjoyment of the dance is the development of a memory of dance movements, aided by an understanding of the structural values of repetition and variation which are the bases of dance composition.

Dance is the most original of art forms, since its only requirement is the body in motion. Its historical origins are not strictly artistic, as it derives from either religious ceremonies or practical activities, or a combination, as for example, as is the case with the Zuni Rain Dance.

Some primitive dances have sexual origins and often are involved in a ritual of courtship. The dances that imply involved in a ritual of courtship. The dances that imply imitations of nature were thought by primitive people to have significant value. In addition to historical forces, another source of dance form is floor pattern movement. The circle, for example, implying rings, enclosure or capitivity, is found in primitive dances, in court dances in Elizabethan time, in ballet and modern dance -- and is a symbol of power in many arts, dance among them.

There are many different occasions of dance which demand formal or pre-specified movements:

Social Dances Done for pleasure of the dancer.

2

<u>Country and Folk Dances</u>	Done for recreational and for social enjoyment, often in costume.
<u>Court Dances</u>	Done during the Middle Ages and Renaissance; more stylized than folk dances, i.e. the minuet, performed by groups of four dancers turning about one another without letting go.

In twentieth century America, there have been two kinds of formal dance, one derived from the other, which are of importance -- ballet and modern dance.

The origins of ballet can be traced to the early 17th century when dancers performed interludes between scenes of an opera. Eventually, ballet itself grew more and more important until it was performed without operatic accompaniment. In the 18th century the en pointe technique, the technique of dancing on one's toes, was developed for female dancers to emphasize light, floating qualities, and today en pointe is the main distinction between ballet and modern dance.

Certain movements began to become standard over the passage of time and to constitute the textural elements of every ballet, similar to the way that keys and scales have become the textural elements of music.

A repertory of ballets has been built up in the last 250 years. The advent of Labanotation, a system of notation of dance movements, has contributed significantly to this growth. A study of this repertory shows that generally, a pretext, or narrative, is central to most ballets, as are certain central movements. Dance, therefore can be said to be a meld of the two, story and motion.

3

All formal dance, whether ballet or modern dance, consumes space in rhythmical time for the purpose of communication. Dance flows from kinesthetic laws of motion applied to body movement and position which dancers use to explore emotions, propose abstract ideas, or perhaps represent life experiences reflecting the human situation.

Grace and agility come from practice of the principles of kinesthetics by the dancers. Facial expressions, arm movements and the placement of hands, the pointing of feet, the rhythm of movement, strength and endurance result in the dancer's artistic skills.

Every movement in a dance is part of a pattern of motion. Bending and reaching are axial movements. Swinging is an even and pendular motion using the legs and arms, or in a full body swing. Twisting, standing or elevated thrusts in the air relate to changes to the center line of the dancers body. Opening and closing movements release and close the center line. Pushing and pulling movements give a dynamic force to the dance. A turning movement rotates the dance around a center axis on one or both feet. To travel in a turn, steps are taken by the dancer, legs lifted off the floor, and the eyes focused on one spot to keep equilibrium. Falling is controlled by thrusting the body weight in the opposite direction from which the body is falling. In a backward fall there is an upward thrust of the leg, with the arms reaching back to the floor lowering the body. A forward fall is a reversal around the axis, complete with the shaking and vibrating of the legs, hands, or torso in tremendous motions. The even transfer of weight in walking or running is achieved by pushing away from the floor by the back foot, knees bending to absorb shock, taking the weight on the toes first, then lowering the heel after the knee is bent. A stronger push from

4

the back foot makes a leap. A landing is done
with turned out feet, landing on the toes, the
same as in running, with the back straight.
Landings may be executed with many variations by a
dancer, but always with the head and spine
remaining straight. Hopping and springing require
the dancer to land on the same foot as in the run.
Sliding requires the dancer to take an inside step
sideward with one foot meeting the the other in
the air after it has come up behind it. To skip
the dancer's weight is sent in the air by a step
and his landing kept on the same foot. The uneven
rhythm gives an upbeat response. During the skip
the back of the dancer is straight with a U arch
at the peak of the skip. In the jump, the
dancer's knees are bent, the back is erect, and he
pushes off the floor with both feet, the toes
pointed downward, the knees bent at the return to
the floor of both feet. Of course there are many
variations of these basic body motions. But all
these basic locomotor changes are based on body
mechanics.

Dance has a number of basic and traditional
positions which are frequently used as starting
points for subsequent movements.

First position -- feet open, hips tight, arms
curved away from the body.

Second position -- feet spread, hips turned
out, tightening buttocks, ready to take off,
elbows back, shoulders down.

Third position -- one foot open, diagonally
forward.

Fourth position -- one foot forward, foot at
instep, arms forward, one arm overhead.

Fifth position -- one foot free of the other,
ready to move sideward, arms overhead slightly
forward of the head.

These positions require the dancer to have strong feet, with the toes pushing down in line with the leg, gripping the floor, keeping the dancer's weight in the transverse arch of the foot.

Two other positions are also of great importance. In the Arabesque the back leg is held high, tension is in the arched back, or with torso lower reaching forward with the back arched. When the leg is flexed, the body balanced in high or low position, the result is what is called an attitude.

The function of the dance itself is communicated through all of these movements and positions. Tone is emphasized by changing the dynamics or intensity of the force of the body movements. Weighted movement, for example, gives a sense of grief; other movements have their own meanings as well.

Slowly downward -- sorrow
Opened-up -- lightness and joy
Angular, broken lines with power -- fear, anger, frustration
Big bursts of energy -- excitement or aggravation
Larger steps done with force -- hate
Soft lines -- kindness; love
Gentle open motions -- peace
Weight to floor -- rage; destruction

Movement is often patterned according to the musical score. The interaction between dancers and music creates communication which suggests the plot. This is particularly so in the pas de deux, a dance consisting of a female partnered by a male, telling of their romance.

The staging of partial arrangements of complete dances follows patterns or formations depending on the number of dancers and focus is given to each gesture to add emphasis. Once these aspects are decided upon by the choreographer who plans the

dance, other effects are created through accessories, such as lighting, stage props, and scenery.

Many of the basic actions and patterns of the dance can be characterized through the following charts.

Action	Time	Weight	Space
Thrusting	Sudden	Firm	Direct
Slashing	Sudden	Firm	Flexible
Floating	Sustained	Fine Touch	Flexible
Gliding	Sustained	Fine Touch	Direct
Wringing	Sustained	Firm	Flexible
Pressing	Sustained	Firm	Direct
Flicking	Sudden	Fine Touch	Flexible
Dabbing	Sudden	Fine Touch	Direct

Basic Space Patterns

a) Straight 1XET
 Angular 7VLWNM

b) Rounded CO 369
 C curves
 O circles
 6 spirals
 3 repeated

c) Twisted S Z 8
 S simple twist
 8 repeating twist
 Z twist with spiral

Body Shapes

Large -- applies to length
 small -- applies to length

Wall-like (spread) YTFK shapes dancing
 cartwheels or star jumps

The Five Body Activities and Stillness

a) Gesture: Which includes all movements
 of the body which are not
 concerned with supporting the
 weight.

b) Stepping: Which includes all transferences
 of the weight from one support
 to another.

c) Locomotion: Which includes methods of trans-
 porting the body from one place
 to another.

d) Jumping Which includes all movements where
 there is no point of support.

e) Turning Which includes all movements where
 a change of the front is made, it
 can be combined.

Jumping -- Five Basic Jumps

1) from one foot to the same foot -- hop temps leve
2) from one foot to the other foot Jete
3) from one foot to both feet assemble
4) from both feet to both feet saute
5) from both feet to one foot sessonne

Thrusting Straight out move

Slashing Whipping up the space around the body
 and the body twists and turns

Gliding Moving hands toward or away from the body

Floating Aimed hand movements -- loose jointed body

Pressing Pushing body toward or inward from the
 hands, shoulders, and hips

8

Wringing	Hands whipped in space
Flicking	Hands and feet flex into space
Dabbing	Hands and feet control a flex into space -- darting

The practice of all these principles of dance, when left to the great professional companies of the United States, results in high art, unreducible to verbal re-creation. However, the history of twentieth century American dance shows that there are a number of troupes in the United States able to transcend the limits of athletic bodily movement and whose work has been most important and is worthy of attention.

The New York City Ballet, under the direction of George Balanchine, was established in 1948 to work within the confines of academic classic theatrical dance. It is permanently based at the Lincoln Center in New York City, at a theater designed for it by the great architect Philip Johnson. Many of the performances staged by the New York City Ballet use the music of Igor Stravinsky as the basis for the perfection of rhythm and gesture for which it is known. With this view, the New York City Ballet is more musically oriented than many others, even when it departs from Stravinsky's scores. Among the most dazzling of their productions have been Stravinsky's Orpheus (1947) and their annual performance of Tchaikovsky's Nutcracker, choreographed by Jerome Robbins, himself of international reputation. They have featured such dancers as Allegra Kent, Jacques d'Amboise, Melissa Hayden, Gelsey Kirkland, Carla Fracci, Edward Villella and Suzanne Farrell.

Balanchine's direction has resulted not so much in development of soloists as in a total performance by the entire corps de ballet.

Additionally, the New York City Ballet spends considerable energy on set design to amplify the body movements of the dancers.

In contrast to the stability associated with the New York City Ballet, the American Ballet Theater is a more eclectic troupe, playing in houses all over the country, with a very wide diversity of dance styles, and featuring diverse personnel.

The American Ballet Theater's production of Pillar of Fire was choreographed by Anthony Tudor and was one of their greatest successes. The dance is done in contemporary style; that is, it is non-traditional in its subject matter, tending toward realism rather than fairy tales, which often provide the plots for ballets. The music for the ballet was composed by Arnold Schoenberg and features patches of seemingly atonal music, a modern musical technique. The ballet is contemporary in theme, as it deals with the maturity of an adolescent girl, giving rise to the topic of the emancipation of women within a classical, Greek context. In terms of dance technique, it is also contemporary in that the torso is played freely after the influence of the Russian Michel Folkine, and that the male and female partners are presented on similar levels rather than the male being used simply as a prop for the ballerina. And finally it is contemporary in that the dance movements which portray emotion are revealing of the psychology of the characters more than is their behavior. ABT's best dances, Swan Lake, Giselle, Petrushka, have featured non-national stars such as Natalia Makarova, Erik Bruhn, Rudolf Nureyev, and Mikhail Baryshnikov. Their presentations depend on that diversity for their success. The repertory of the company is probably the widest possible. Their willingness to appear on public television is testimony to their liberal attitude toward performances.

Of slightly less stature, the Robert Joffrey Ballet, led by its resident choreographer Gerald Arpino, features contemporary dances such as Deuce Coupe by the innovative Twyla Tharp, showing the Joffrey's up-to-date qualities.

Similar to the Joffrey in their contempory style, the Alvin Ailey Dance Theater is a racially integrated company whose success depends on the interplay of pure modern dance with pure ballet. Their style is based on the success of an earlier similar group, The Katherine Dunham Troupe. Occasionally using rock music, Ailey's dancers combine elegant line and sexually suggestive movements to produce an evening of excitement. The most famous dancer of the group, Judith Jamison, is able to combine the athleticism of disco dancing and the tension of a ballet in such pieces as Revelations.

The doyenne of dance in America is, of course, Martha Graham. She has created hundreds of dances which develop repetitive movements suggestive of tension and release by emphasizing a spareness of line movement. The combination has been most effective in Time of Snow and Night Journey, whose set was designed by the sculptor Isamu Noguchi.

Merce Cunningham is perhaps the most imaginative choreographer. He uses jazz, rock, and symphonic music. The improbable combination of music by John Cage and the flowing, sometimes jumpy, movements of Cunningham's dancers is a revelation of cross-purposes.

The success of Twyla Tharp, who performed for a while in the Paul Taylor Company, typifies the current development of modern dance. Her first efforts were dances almost abstract from plot, exercises of bodily movement in space and time. She changed direction to utilize artifacts of American culture as a basis for her works. These

11

artifacts, apparent from the titles of her works, Eight Jelly Rolls, The Bix Pieces, The Raggedy Dances, and Deuce Coupe, make use of jazz and rock 'n' roll. Duece Coupe is a dance of five company members, fifteen ballet dancers, and some teen-agers who mimic painting graffiti on a wall to the rhythms of contemporary rock music. A later effort, Sue's Leg, tells the history of popular dancing and popular music during the late twenties and thirties. Tharp's material for dance, then, sometimes comes from the art form, creating and re-creating.

BRIEF DANCE HISTORY

The beginnings of American dance are wholly
derivative. In 1916 and 1917 Diaghilev's Ballets
Russes made two tours of United States cities
without overwhelming popular success. The tours
emphasized exoticism and eroticism in costume,
performance, and to some degree in their promo-
tion. The audiences consisted of highbrows and
curiosity-seekers. But to many, it was high art,
a new form of dance to complement the choreography
of dance halls and popular ballroom styles, despite
the morally equivocating reputation it had for
Americans infused with Victorian Puritanism at the
turn at the century.

America, even then, however, responded to
stars, and the big names of European ballet were
attached to this tour, in successive years,
Pavlova and Nijinsky. Both recognized America as
a fertile place for their art of dance and re-
turned to become leaders of that developing art
form as when World War I engulfed their native
Europe. Pavlova, for one, went on to Hollywood,
starring in films featuring her dancing, repeated-
ly toured the country with a repertory company,
and, by a combination of personality and talent,
raised dance to a level of acceptability and art
in America.

America, at the time, was not without its own
serious dancers; it had just not accepted them or
their art. Two of the most important were Isadora
Duncan, and Ruth St. Denis, both of whom danced
extensively in Europe before reaching significance
for American audiences. Both began as dancers in
plays, gradually escalating their dances to
full-length performances. Both were great in-
fluences in the development of American dance.

13

Duncan is thought of as the mother of American dance, despite the fact that her tours were not fully popular. Her influence, like that of the Ballets Russes, was derived from her image. Beautiful, intellectual, and an incorruptible believer in dance for art's sake, she derived plots and characters for her dances from classical sources, but danced in natural loose clothing, barefoot, thereby combining for her audience rationalism and romaticism, the two mainstreams of style of all American art during the nineteenth century. And she was "different" from the Europeans in that her style emphasized a connection to the floor by its solid stance rather than the airiness of the Russian leapers. By performing and teaching she inspired and led others to the dance and freed them of the earlier strictures derived from the European model, allowing for a "different," and American, form of dance. Her individualism in dance style and lifestyle allowed personality to come to the fore of American dance and to be exploited by choreographers in later years.

Early in her career, Ruth St. Denis was a showy theatrical dancer, who made great swoops around the stage in counterpoint to some fragile repetitive movements. She and Ted Shawn founded a school and dance company in 1915 in Los Angeles which proved to be the main source of American native dance. They were influences on many dancers, such as Martha Graham and later Twyla Tharp to name just two. Paradoxically, they became so influential, not because they developed an individual style, but rather because they did not. The Denis/Shawn arrangement, as it came to be called, was open to all manner of influence and suggestion, a diversity which gave them "Americans" as distinct from the classicism or exoticism of foreign ballet.

14

St. Denis was first a concert dancer in
Europe in the exotic style, while Shawn
originally was a dancer with a strong masculine
European style. What they did was to abandon
these limits and adapt dance styles from all over
the world to their purposes. St. Denis tended,
however, to favor Orientalism, and Shawn Western
athleticism. The resulting union of these
apparently irreconcilable styles gained mystique
because of the ambivalent sexuality that both
added to their own roles, and to the roles of
their students. Needless to say, this combina-
tion appealed to those wishing to overthrow
Puritanism in the arts. It is fair to say that
their popularity and influence is related to the
attack and then the change of values at the turn
of the century which is also reflected in the
other arts of that time.

Like Duncan, Denishawn made it to the movies,
in D. W. Griffith's Intolerance, and toured
extensively, bringing dance not only to the major
cities of America, but also to the new industrial
towns which were growing at a tremendous rate,
such as Sandusky, Ohio, impressing audiences with
their theatricalism, which was similar to what
the provincial audiences expected of the famed
and infamous Ballets Russes.

Denishawn is also important in another way.
Because they stretched ballet rules beyond the
breaking point, they were developing a form of
dance beyond accepted norms, relying instead on
individuality. They were developing what is now
called, to distinguish it from the formalism of
ballet, "modern dance." In so doing, they opened
the dance up to new themes and movements, and to
new performers who did not have the physical
proportions of classical ballet dancers.
Therefore, Denishawn is at the foundation of a
new American art form, modern dance, a form which
features what Americans like to believe are
American traits: freedom and individuality.

15

Three important choreographers followed the direction of Duncan and Denishawn, although nominally in rebellion against them, seeking their own individuality. These were Doris Humphrey, Martha Graham and Helen Tamiris.

Humphrey was previously a choreographer for Denishawn. She created two important dances after she left, among the many of her great creations. Air for the G-String takes Denishawn's outright inclusion of dance movements borrowed from other cultures as well as mimes of actions, but the choreography reduces them to the level of suggestion through fine symbolic movements expressive of the original sources of these movements. Additionally, she emphasizes horizontal movement in almost equal proportion to the traditional importance of vertical movement. Both of these stylistic development freed the dance from previous restrictive forms.

Water Study further abstracts upon the narrative movements upon which it is based, so that it is a series of images of water rippling, flowing, even draining, all done in absolute silence. The whole is a challenging abstract piece which bears similarity to the motifs being studied by abstract expressionist painters at the time of its conception in 1928.

Graham's greatest, most innovative, and most influential dance is Lamentations, first done in 1930, then later made into a film. In this dance, the dancer does not walk, run, or jump -- there is no locomotion about the stage. The dancer sits on the stage, encased in a purple jersey which fits tight enough so that the audience can see the dancers bodily movements only in indistinct outline. The format forces attention to the changes of form within the jersey, in what is, for the audience, a study in depth perception.

16

On a bench, legs and arms spread, feet on the floor, the dancer proceeds through a series of movements of tremendous tension and release, suggestive of mournful lament. The shapes that the dancer always fluidly, but sometimes with a styled abruptness, assumes are less physically human shapes than they are the shapes of human emotions. The figure of tragic grief is suggested by forms taken by the dancer in exploration of the depths of that motion. An uncontrolled wrenching cry, a dive into the grave, a strangling, all at various times show the relationship of movement to grief.

Helen Tamiris emphasized glamor and dynamism in her dances which dealt with social problems of the 1930's. She used jazz, rock, spirituals, and sexuality by means of dance movements essentially mime-based in their original conception. Generally, each song develops one of these mime movements, exploring its bases through a series of interpretations and re-interpretations requiring her characters to change the point of view of the given role. In a sense, her dances link folk art with high art through aspects of popular social consciousness.

During the Depression years, the dance in America became patriotic, as did the other arts. But by the mid-30's, choreographers began developing an American dance form from the social consciousness of Tamiris, the ritual of Graham, and the world-wide view of Humphrey and her co-worker Charles Wiedman.

The Federal Theatre Project of the Works Progress Administration during the Depression aided the dance as it did the theatre. Frankie and Johnny, co-choreographed by Ruth Page and Bentley Stone, is a fine example of how the patriotism of the Depression could be welded to dance theatre. The story of a woman and an

17

unfaithful lover is linked to the legends of the
Western frontier. Here it is played as a tall
tale, a particularly American brand of humor, and
done mostly in a mime style. It features, as do
most American tall tales, the exploits of the
bottom class of American society. It provides
entertainment for those who see themselves in
positions superior to those in the story. This is
essentially the formula employed by Mark Twain,
and other local color writers who are enduringly
popular, and is here adapted to modern dance.

Other 30's and 40's dances similarly feature
stories of Americana. Eugene Loring's Billy the
Kid, with a score by Aaron Copland, Rodeo by Agnes
de Mille, and Jerome Robbins' Fancy Free in 1944
are examples. The latter is the story of sailors,
who dance in less exaggerated, more "realistic"
style than was the norm at that time, as they
cavort on leave in New York City. Really, it is
simply a girl meets boy story, complete with a
fight. The score by Leonard Bernstein helps to
meld the classical dramatic steps of the dancer
with seemingly spontaneous and natural movements
within a jazz context.

Martha Graham's Appalachian Spring, with its
score by Aaron Copland, is, in the view of many,
the best of the dances which features aspects of
Americana. It is the last of its kind in Graham's
repertoire before she switched to classical
sources for her choreography. It features a
female protagonist who preceeds through a
narrative consisting of episodes typical of the
lives of the character being depicted, in this
case a marriage in the rural setting of
Appalachia. Each character, with the exception of
the choral figures of the preacher's attendants,
has his own indiviualized movement. Each figure
enters in procession, gravely attuned to the

seriousness of the ceremony. While there is no
plot, as such, the dance is revelatory of the
concerns of each of the characters concerning the
event -- the Revivalist Preacher, the Pioneer
Woman, the husband, the bride, and then collec-
tively, the four females attendant to the
Preacher. Each character performs solo dances,
with the others functioning as witnesses, and
duets with another character; groups dance in
conjunction with some of the other characters
during transitional points where one soloist gives
away to another. As a series of dancers, they are
all related in movement only at the beginning, the
end and during the vows of matrimony. The con-
ception emphasizes the isolation and yet the sense
of community of the Appalachian area.

Each of the characters is a well-developed
entity. The Pioneer Woman is serious and
personally individualistic in the sense of having
recognizable eccentricities. The Husbandman is
also serious, but more dynamic and lively, if not
freer of imagination than the wife. The Revi-
valist preacher is authoritarian, a peacock of
vanity with his entourage of women to whom he
plays, but essentially a straight-laced figure --
an ambivalent portrait by Graham of formalized
religion. The wife is a problematic figure,
seemingly detached from the action, yet partaking
in it. She runs, at times in the dance, to the
groom as if to join with him, then stops or pulls
back. Gradually, she establishes a relation
through dance to the husband, the home, and the
baby, figured in the dance, but draws back again
after the fire and brimstone sermon by the
preacher with her depiction of deep foreboding of
some impending familial tragedy. The husband's
role is mainly to reassure her, to accept and
comfort his bride.

Taken together, the unity of floor space, the
understanding of the region, and the dynamic roles
of the characters gives this dance universal
attributes which mark it a classic.

Of course, there are many other dances and choreographers that could be discussed here because of their clear conception of movement, meaning, and music. Two, dances however, particularly utilize new developments within drama and music and meld them with those of the dance to create performances which are historically and aesthetically important. These two dances are Ivesiana by George Balanchine and Revelations by Alvin Ailey.

Ivesiana was originally done in 1954, but has been changed in the course of production many times. These alterations make it difficult to give a firm analysis of the dance, its narrative, movements, and the like. In any case, Ivesiana is a series of vignettes with few overt relationships between them. Originally, there were six vignettes; but that number changed from production to production, as did the accompanying music. Much of the dance itself, as well as the music, seems to be randomly done, not to say surrealistic, gloomy, futuristic, and disquieting.

Arhythmic, atonal chord progressions, typical of Charles Ives' work at the frontiers of formal music in the twentieth century in America, alternate with a fundamental jazz line. To this kind of music the dancers perform on a dark stage. A choral group dances in witness of a male and female dancer seemingly establishing a social relationship in the opening vignette, called "Central Park in the Dark." The viginette bears similarities to Scene V in Eugene O'Neill's play The Hairy Ape in its expressionistic presentation of scene which may or may not be "real" and may or may not be a projection of a character's emotional state.

Another vignette, "The Unanswered Question" is accompanied by a score which consists, seemingly, of a scale that the instruments in the orchestra

simply do not want to play. Woodwinds and brass, as in other Ives pieces, play in contretemps to the strings, the tension between the two creating the sense of a question being asked, but not knowledgeably answered. In the dance, a woman is held in the air by four men who present themselves as a barricade to the male dancer trying to get to her. They pass her around, all of them assuming odd shapes, manipulating her in ways shadowed by the music, until the end when everyone goes offstage, the male dancer still not having gotten her. She never does touch the floor from beginning to end. This is perhaps the enactment of the role of the bitch-goddess, a theme popular in such diverse works in American arts as Hemingway's, The Sun Also Rises, in literature, de Milles' films in cinema, and in the work of various modern painters and sculptors.

A third vignette, "In the Inn," by contrast to these two vignettes, is lively, bouncy, jazzy, until it abruptly ends -- a disconcerting ending undercutting the fun of the whole with a sense of fear, as a boy-meets-girl scene fizzles.

"In the Night," features a dark stage, thirty--five dancers crossing it in various angles, some leaving the stage, but others entering and replacing them. The music is calm with only periodic bursts, the combination of dance and music seemingly terroristic in its contrast of unity and individualism.

Alvin Ailey's, Revelations represents a completely different nexus of influences than does Balanchines' Ivesiana.

The Alvin Ailey Dance Theater is a racially integrated troupe, but emphasizing black dancers, choreographers and themes, expansive, even theatrical body-movements and vivid constumes. The style is part ballet and part modern dance,

21

rife with influences from any area of dance and modern culture, including those of Africa and the Caribbean, and those particularly American, such as rock 'n' roll and jazz. Just as Ivesiana has changed through successive production, so has Ailey's Revelations, which premiered in 1960, and evolved, generally getting larger and more complex, since then. Its greatest performances, however, have featured the tall, snaky black Judith Jamison, and the powerful, tall Dudley Williams as lead dancers.

There are three sections to the dance "Pilgrim of Sorrow" is quiet and thoughtful and spiritual in tone. "Take Me to the Water" is lively, a celebration of the sacrament of Baptism. "Move, Members, Move" addresses sin, evil, and, finally, pleasure as the desires of all who live on earth using lively jazz motif.

Through all the sections, the dance movements suggest the essence of black, rural county life, including its suffering and joy, body aches and soul aches, triumphs and shames. Some parts are poignant, as in the movement where the dancers suggest the muscle cramps afflicting cotton pickers, and also in the section expressing the ecstasy of salvation depicted in the flapping arm movements of Judith Jamison, who, carrying an umbrella, witnesses the baptism of the man and the woman.

The alternation of mood, and above all, the sheer energy of the dance and the black music, jazz and Negro spirituals alike, bring the audience to interrupt the performance with shouts and applause. The audience's reaction becomes a part of the energy of the dance itself. The finale, a wild, but controlled dance features the umbrella women rollicking to "Rocka My Soul." This final part finds everyone in the audience singing, clapping and screaming, as the hall takes on the atomosphere of a revival meeting.

Revelations brings together to the dance the rising influence of black artists, and the black heritage, similar to that which occured in theater during the same time; for example in Lorraine Hansberry's Raisin in the Sun, and the high energy levels of the black music idiom brought to the stage in The Wiz, a black version of The Wizard of Oz. Revelations, built on native America popular music and popular culture, elevate American dance to high art.

DANCE

Recommended Reading

Braun, D. Duane. Toward A Theory Of Popular
 Culture: The Sociology and History Of
 American Music and Dance 1920-1968. Ann
 Arbor Publishers, 1969.

Hodgson, Moisa. Quintet: Five American Dance
 Companies. New York: Morrow, William, and
 Co., 1977.

Laban, Rudolf von. Principles of Dance and
 Movement Notation. Brooklyn: Dance Horizons,
 1970.

Magrid, Paul, ed. Chronicles of the American
 Dance. New York: Da Capo Press, 1978.

Martin, John Joseph. Book of the Dance. New
 York: Tudor Publishing Co., 1963.

Palmer, Winthrop. Theatrical Dancing in America.
 Cranbury: A. S. Barnes and Co., Inc., 1978

Siegel, Marcia B. The Shapes of Change: Images
 of American Dance. Houghton Mifflin Co., 1977.

Stearns, Marshall, and Jean Stearns. Jazz Dance.
 New York: Oxford University Press, 1962.

Terry, Walter. The Dance in America. New York:
 Harper and Row, 1971.

24

CHAPTER II

MUSIC

25

A BRIEF OVERVIEW OF "ORCHESTRAL" MUSIC

Music is the most complex of arts, a form which is pure in that it, like dance, is verbally unreproducible. A few short definitions in series make an efficient statement of basic concepts of music.

<u>Sound</u> Tonal relationships

 Noise Movement in the air in the form of a wave.

 Tone Dominant frequency of a sound; may have partials (tones) sounding simultaneously.

 Tone Color Relative loudness of a partial (varies from instrument)

 Consonance Two or more tones sounded together pleasingly.

 Dissonance Wave interference produced by two or more tones (beating). Generally found when notes close to one another in pitch are sounded simultaneously, (CD, CB).

<u>Tonality</u> Major Scales

 C major - white keys on piano CDEFGABC

 F major - FGAB & CDEF

 Most important notes in C scale

```
Tonic C
Fifth (dominant) G
Third (mediant) E
Seventh (leading tone) B
Eighth (tonic) C
```

Compared with events transpiring in Paris, Berlin, and Vienna, music in the early twentieth century in America is of small value. The lack of audiences and facilities in the United States made this country a backwater of musical growth. In fact, what few performances there were in a handfull of American cities were usually the work of foreign authors and players. Indeed, so bleak was the American scene that native talent left America for Europe -- John Knowles Paine and Edward Mac-Dowell to name only two. Despite the morose condition of the American musical scene during these years, two significant events began to take shape -- that is, American ragtime and jazz began its journey to the world's ears and Charles Ives began his experiments with new tones and arrangements for orchestral music.

Born the son of a band director in Danbury, Connecticut, Charles Ives was influenced by his father, who sought to imitate everyday sounds in his compositions by using musical instruments after modifying them to produce the sounds he desired. His compositions ranged from the antiphonal to the polyphonal, featuring unexpected dissonances.

Yale and Harvard at the time had widely respected, if not internationally famed departments of music. Ives went to Yale, then migrated to New York where he supported his musical interest by working in the insurance industry.

It was not, however, until the 1930's did Ives' work begin to be performed in front of audiences of any size. Then his musically reclusive background gave his complex music an aura of power that made it imperative for serious musicians to know. Two

movements of his Fourth Symphony were played in New
York in 1927; but it wasn't until 1939 that Concord
Sonata was heard in New York with positive response.
In fact, the Third Symphony, for which Ives received
the Pulitzer Prize in 1947, was written during the
late twenties. And it wasn't until 1965 that it was
completely performed in New York, and only then
through a grant by the Rockefeller Foundation.

Among his works Ives wrote four symphonies, four
sonatas for violin and piano, over a hundred songs,
and other small pieces. Much of it was written
before World War I. A dominant mode of composition
which Ives featured was to use a free prose meter
with long periods of normal tonality, alternating
difficult and simple sections and adding some popu-
lar music for brief stretches or fragments. The
totality is very expressive, but jarring, because
there is more contrast than similarity as a basis of
the composition.

Ives, however, was not alone in the development
of American symphonic music. Roy Harris took a
Guggenheim fellowship to study music with Nadia
Boulanger in Paris and returned to the American West
to write, numbering among his works some eleven
symphonies, a concerto for two pianos, and a violin
concerto. His very short seventeen minute, Third
Symphony, written in 1939, with its five sections
linked without pause by a common theme, marked him
as an important American composer.

In his study of music, Harris developed a theory
of modes -- seven modes in an order from dark to
light -- the forms are those whose tones form small,
or diminished, intervals with minor or tonic tones.
Such a theory completes his chords theory, con-
sidering them to be "bright" when they resemble the
overtone pattern in structure, or dark when they
differ from it. These ideas make his music simple
and create long melodies, strong rhythms, and a
tonal sound.

28

Walter Piston, from New England, also studied
with Nadia Boulanger in Paris. He also received a
Guggenheim, as well as a Pulitzer Prize. He has
written seven symphonies, a piano concerto, two
violin concertos and a viola concerto, as well as
many pieces of chamber music. His works employ a
classical repertoire with complex harmonies, strong
key relationships and forceful rhythm.

These writers' main works were composed in the
1930's and 40's. Among later American composers
Samuel Barber stands out. Two operas by Barber,
Vanessa (1950) and Anthony and Cleopatra (1966),
written for the opening of the Metropolitan Opera
House in New York, are most noteworthy. While
opposite in temperment, they reveal a classicism
which one would not normally associate with the
period of social and artistic turmoil in which they
were written. They are replete with ensembles and
arias and tell old-fashioned love stories.

Barber's work contrasts very sharply with that
of John Cage. During the 1950's and 1960's,
experiments by composers sought to stretch the
bounds of music. In addition to the development of
twelve tone music by Schoenberg and others, there
developed aleatoric music, or chance music, which
consists of partially unplanned happenings during
the musical composition and performance. Scores
have unusual notations with, at this point, no
uniform method of notation internationally adopted.
Furthermore, the repertoire of music was expanded
with the advent of technical advances, using tape
recorded splices and musicalized noise, developed in
part from physics experiments in ways to create
musical sounds. Sometimes electronic music was
produced by electronic oscillators rather then by
traditional instruments. Cage's Fontana Mex con-
sists entirely of noise, sounding as if one were
turning a radio dial through the stations with lots
of static; there is laughter and a dog barking in
the background.

The variations of random or unusual sound
production and performance are of course unlimited.
But a limit of sorts was reached in two different
performances by Cage. In one, he attached
microphones to his throat and drank a glass of
water. In another of Cage's works, a piano is not
played for four minutes and thirty-three seconds --
a performance in silence -- while the performer
sits at the keyboard, unmoving except for opening
and closing the fall board to denote successive
sections of the work. Cage wants his audience
"simply to wake up to the life we're living,"
listening to the random sounds of life in the music
hall, of coughs, body movements and the like.

Two other highly unusual composers in America
are Elliott Carter and Milton Babbitt.

Carter also studied with Nadia Boulanger and
developed an extremely complex style in which there
is no blending of sounds. In some of his works
each instrument plays different figures and rhythms
from any other. In fact, Carter's pieces are meant
to be heard more than once; recordings of his music
are to be played consecutively so as to determine
their artistic content.

Babbitt, a renowned music analyst and critic,
has had a leading role in arguing that music can
rightly be written for a small, but limited
audience, in the same way that modern poetry is.
Babbitt's music writing has centered on creating
pieces for electronic musical instruments, mainly
the synthesizer. He developed interest in this
type of music through his writing, his musician-
ship, and his teaching at American universities.

It is widely believed among music historians
that these American authors were part of an inter-
nationally critical period in which the tonalism
and metricalism of the late 19th century were being

challenged by the new atonalism of which Ives and
Babbitt were a part. Like figurative painting being
challenged by abstract expressionism, music was
challenged to discard tradition and to exalt the
individualistic expression and the novel form.
Gustav Mahler, Scriabin, and Sibelius all wrote
early twentieth century symphony containing the
beginnings of atonalism.

Arnold Schoenberg meanwhile, brought Richard
Wagner's ambiguous tonality to the forefront in one
of his earliest symphonies, developing it almost to
the point a new style, while more traditional
approaches emphasized traditional Romanticism made
more and more complex. Opus 10 by Schoenberg (1908)
begins his atonalism, which he developed in later
works. It was an atonality which was not contained
within prescribed boundaries of scale, or by any
other means.

Ives "The Unanswered Question," which found its
way into modern dance, was written at about the same
time as Schoenberg began his development of
atonalism. This work centers on a series of notes
which seem to ask a question, repetitively; but the
chorus, at the end, has no answer. A string
ensemble, a trumpet, and a woodwind quartet play
tonal triads, but the trumpet is the atonal
questioner. Against the background of woodwinds,
the non-answers, respond atonally amd ambiguously,
seemingly in a broken pattern, until their final
non-answer, in a progression of increasing
atonality, is completely unpatterned. The final
time the trumpet asks the question, the woodwinds do
not answer; instead there is only the tonality of
the strings. The final answer seems to be the wrong
one.

This piece mirrors the revolt in music of the
first half of the century. Tonal composers reached
for atonality. Atonal composers, in their com-
mitment to finding a new form, pressed on in their
search, writing atonal music increasingly disjunct.
All were striving for new means of expression.

Igor Stravinsky worked the tonal side, leading twentieth century development, Schoenberg the atonal side, trying to turn the tonal system into an entirely new structure. Schoenberg actually took his view from his observations of developments in the other arts, as he himself was a painter in the expressionist's style. His Opus 23, takes 23 poems by the French writer Albert Girot and introduced the technique of sprechstimme -- the singer quickly jumping off his notes, producing a cross between singing and talking. The result is to give atonality to the vocal instrument. The effect is unreal and grotesque.

The difficulty in writing this music was that tonality tended to creep in despite efforts to keep it out. Atonality, in a way, became its own worst enemy. To combat this, by the late 20's, Schoenberg evolved a serial method using the systemic twelve tones constantly but not in relation to each other. They are given an order, and no tone repeated until the other eleven have been sounded. While there are other aspects to this system, this fact of repetition of the tone row is the fundamental idea of Schoenberg's system. Some notes may be combined into chords, others used as melody, for example; but all twelve are used in a given order or sometimes a permutation of the order. Thus there is a control, a structure, to the atonality, and bound atonality rather than free atonality. In a sense, the row replaces the scale as a structural fact of the music composition.

Alban Berg, Anton Webern, Schoenberg students, and later Babbitt and others adopted and adapted serialism for their compositions, all but abandoning tonality.

The artificialty of the system forced formalistic concerns to take precedence in the composers' thinking. Stylistic simplicity became the ideal in symphonic music, as it did in

32

Modernistic architecture, and abstract expressionism painting. The style emphasizes serialism and repetition, as do the glass skyscrapers of the international style and paintings in the constructed style.

However, tonality continued to find its way into all of Schoenberg's work. In fact, as late as the 50's he wrote a tonal piece in G-minor towards the end of his life. Some feel his late return to the writing of tonal music was an attempt to get his music performed, since serialism was never an audience-getter for Schoenberg or for the other atonalists. Others feel that tonality always was a condition of his love of music and of his work as a whole. He always recognized, however, that the twelve tones of the row were still the same twelve tones of all composers, just re-arranged in conception, and that the notes have an inherent tonality themselves. In short, Schoenberg and others in their experiments served to prove that tonality was a given of music, that it was inescapable.

Ironically, when Schoenberg dies in the 50's, Stravinsky switched to writing tone row music, only to give it up himslef in the end, recognizing that the mathematics of it over-rode aesthetic concerns. Others, however, found the mathematics of the tone row a gold mine for "avant garde" music. At this point, atonalism had become an academic exercise.

Conversely, tonalism became the new area of development, what with the death of the leaders of atonalism, Schoenberg and then Stravinsky. As in the other arts, music turned to its traditions, incorporating within it lessons learned during the period of atonalism, and all the experimental forms of the first part of the century embedded within traditional tonalism.

Karlheinz Stockhausen, Benjamin Britten and others have written works which synthesize the erstwhile "avant garde" with the traditions of

33

classicism. Their work demonstrates the return to
traditional forms in music which is similar to that
in the other arts -- a tradition enriched by the
expressionistic experiments of the first half of
the century.

However, while some composers debated the
merits of tonality, others continued to write
mesmerizingly tonal pieces. Perhaps one of the
greatest pieces of music written in America in the
twentieth century is Aaron Copland's Appalachian
Spring, written during 1943-44 for the dance of the
same name by Martha Graham, a hallmark in American
dance. Funded by the Elizabeth Sprague Coolidge
Foundation, Copland won a Pulitzer Prize for this
work. In 1945, he further developed the music for
the dance into a concert suite requiring greater
orchestration than did the music for the dance.
The dance's original theme of the Shaker cele-
bration in rural Pennsylvania of spring and
marriage provides Copland with material to develop
new music based on Shaker hymn styles, although
only "Simple Gifts," one tune in the suite is
Shaker in origin.

He uses folk-based melodies in Appalachian
Spring to develop strong tonal patterns by using
triadic harmonies, rhythms of shifting emotions and
a sonorous melody. The piece consists of eight
sections with developments of a succession of
related themes.

The first section, which corresponds in the
dance to the introduction of the characters,
develops the basic harmonic line of the A-major
triad, which is used throughout the remainder of
the piece to signify the emotions of excitement and
expectation. Set off against this line is that of
the contrasting emotions of serenity and acceptance
of an A-minor arpeggio. The second section uses
the strings to show the elation of the marriage
which is impending. The third section relates to

the bride and groom showing their love through its use of the A-major triad and modulations from B flat to B major. The fourth section is concerned with the Revivalist Preacher and his attendants and borrows from the techniques of country-style fiddlers to show celebration. The fifth section corresponds to the bride's alternating feelings of reservation and joy about being a wife and mother, and is extremely fast. The sixth section, by contrast, is very slow and is similar to the music of the introduction and section two. The seventh section presents five variations on a Shaker theme, meant to suggest work of various kinds on the farm. The theme of this section is presented by a lone clarinet playing a complex system of variations on the theme, backed by varied orchestration, and ending with a chorale. In the eighth section, a coda complements the music of the introduction, corresponding to the dance's conclusion of the bride and groom sitting at their farm. The finale is quiet, suggestive of their final serenity, and played by the strings.

Appalachian Spring, relies on tonality derived from folk sources, and adapts the methods of development of theme by means of counterpoint, augmentation, and repetition, that "old-fashioned" baroque composers used, to produce an enchanting work fife with the traditions of American culture.

Marking the direction that music has taken in the late seventies was the award of the Pulitzer Prize for music in 1979 to Joseph Schwantner for his melodic "Aftertones of Infinity." According to Schwantner, this piece is a conscious effort to simplify the techniques of music, to move away from the complexity and the dissonance of his earlier works which shared, at that time, characteristics of contemporary composers.

In the 70's the 12-tone scale or serialism propounded by Schoenberg had led many composers,

35

Schwantner and others, to newly discover techniques of rhythm, melody and harmony. Chance music, aleatoric music, electronic music, all which were never accepted by the general audiences, were gradually being left behind by those once again putting tonality ahead of all other compositional structures. While this tonality is linked to the "romantic" music of the past, it benefits from the previous experiments of the new music, and is a synthesis of the romantic and the serial. The result is music which is listenable and understandable. It is music which is traditional yet new, and typified by Schwantner's "Aftertones of Infinity."

The shift back to traditional structures, abetted by aspects of the previous period of experimentalism, is clearly present in formal music as it is in the other arts, at the beginning of the 1980's.

A BRIEF OVERVIEW OF POPULAR MUSIC

While formal music in America during the twentieth century has a plainly international cast to it, popular music is much more individualistic in its growth, its nativeness to America, and, in fact, in its impact on the art of the world.

In the beginning of the twentieth century, the Industrial Revolution and the annexation and the granting of statehood to western territories gave American thought an optimistic tinge. These feelings were given expression by the music written by George M. Cohan in such songs as "Yankee Doodle Dandy" and in the marching and bandsmanship of John Philip Sousa. The usage of brass, woodwind, and percussion instruments with a fast rhythm produced an upbeat tempo which matched the expansiveness of the times. It led to new dance steps and ultimately to the leadership role that America took in developing a new form of music.

Among nineteenth century American composers, Stephen Foster was the major writer who broke from the European tradition of light, romantic music to develop a style using techniques employed in the music of Afro-Americans in the South. Foster, however, applied these techniques to European-style ballads.

Black artists, meanwhile, among them Scott Joplin began to write and perform music with a steady two beat march rhythm played in the left hand and a persistent syncopated rhythm in the right hand. Called ragtime, it revolutionized popular music in the United States.

Because of the wide latitude of possible combinations, the music could be very complex, in fact, too difficult for the average pianist. But it

became widely played for two reasons: 1) musicians
diluted it to simple formulas and 2) technological
developments in the music industry made it easier
to perform.

Player pianos became household items. Songs
could be heard by placing a role pierced with holes
into a slot in the piano. Presto! Music would come
out when the piano's foot pedals were moved.
Representatives of song publishers mapped out routes
to plug songs so that popular singers and bands
would perform; and then the representative would
move in to sell their music. One part of the
industry fed off the other. Ragtime took advantage
of the technology and marketing to become popular.

White composers took ragtime to even greater
prominence by writing, playing and reproducing their
own ragtime music. The most famous ragtime song,
"Alexander's Ragtime Band" was written by Irving
Berlin, a white. White covering for black music was
to become an institution of American music.

Easy to dance to, ragtime became a moving
force behind an entire group of new dances. The
popularity of record discs, cyclinder records,
phonographs, and victrolas allowed people to listen
to the new music and practice their dance steps in
their own living rooms. The popularity of this mode
of entertainment increased with a variation on
ragtime that spawned a whole new legion of music
followers -- jazz. It was a style developed by
black musicians in New Orleans, such as King Oliver,
and popularized on records by the original Dixieland
Jazz Band. Like ragtime, jazz employed a two beat
marching rhythm, but with the instrumentation of
the marching band, a trumpet or trombone, or a
clarinet, playing melody, and a rhythm section of
drums and piano. Whereas ragtime employed a
syncopated rhythm with the right hand, jazz
allowed complete improvisation on top of the
basic rhythm. Each performance of jazz, therefore,
resulted in a new composition. The orginal

Dixieland Jazz Band utilized still another device in its music, the blues technique of sliding from one note to another, in its drive to popularity.

The 1920's have come to be called the Jazz Age for the music sung by Al Jolson, Sophie Tucker, and Ted Lewis, and played by popular bands like Paul Whiteman's during that decade. Almost all popular music of those years was affected by jazz. All the orchestras featuring the new music had a rhythm section of piano, banjo and, later, the guitar, bass, and drums, which were integrated into the improvisational technique which the band featured. The sound was popularized by a new contraption, the radio. The pleasure seekers of the 1920's, personified by the flapper, listened to artists playing in front of the bands. The music played by these soloists extended the range of the music. Lionel Hampton and his vibraphone were an example. The jazz beat captured by the brilliant arrangements kept alive improvisation in a smooth organized performance.

The bands played all over, hotels, ball rooms, and movie theaters, the hottest of which was the New York Paramount Theater. Carnivals featured twenty-five bands in competition. There were band contests in concerts attended by scores of thousands of admirers. Benny Goodman, who was the first to have an integrated band, and many of whose musicians later formed their own bands. Artie Shaw, Count Basie, Tommy and Jimmy Dorsey, Cab Calloway, Louis Armstrong, Lionel Hampton, Gene Krupa, and Harry James drove off the disaster of the Depression with their music at least temporarily for their hordes of fans. Come the New Deal era, the sound became the beat of the nation.

Of the big bands, the best was the band of Duke Ellington. In 1939, Ellington added to his band a lyricist, composer, and arranger, Billy Strayhorn. Strayhorn had the good fortune of working with a

band having little flux of personnel. This com-
bination resulted in the Ellington band's greatness.
Strayhorn was able to unify the indenity of the band
while it was composed of strong individual players,
giving them the freedom of expression basic to jazz.
These things put the Duke Ellington Band ahead of
the rest from the 20's to the 70's.

Taking Ellington's ideas and merging them with
the modern jazz ideas, Charlie Mingus, a composer,
arranger, and bassist, developed a small band that
was the outstanding practitioner of modern jazz.
Besides playing with Ellington and Charlie Parker,
Mingus also played with Art Tatum, Kid Ory, and
others. Their influence led him to incorporate
aspects of church music, and rhythm and blues, into
the modern jazz idiom.

The jump bands, which played jazz in an uptempo
style suitable for dancing, came to popularity
following the fall in importance of the Big Bands.
They kept popular music in America developing
despite the general popularity of mellow music.
Among these bands were those of Lionel Hampton, and
Louis Jordan. Jordan was perhaps the most suc-
cessful recording artist of the 40's, and was active
into the 50's and 60's.

Two other jump bands were of importance to the
development of rock 'n' roll. The Timpany Five Band
influenced later rock 'n' roll performers like Bill
Haley and Chuck Berry. The band featured a saxo-
phone performing in front of the orchestra.

T-Bone Walker, influenced by Charlie Christian,
and, in turn, an influence on Chuck Berry, used
feedback effects with great success. Additionally,
he was a great showman who played the guitar while
doing splits, played it behind his head, and during
all manner of body contortions. Berry's famous
duck walk, which drew tremendous audience reaction,

40

was directly an outgrowth of T-Bone's performing style. And rockers have followed Berry's style ever since.

Many of these jump bands came out of Kansas City. The songs of many of them were later made into big hits by white rockers. An example is Wynonie Harris' "Good Rockin' Tonight" which later became a big hit for both Elvis Presley and for Buddy Holly.

Similarly, developments in modern jazz musicianship, while important in themselves, also affected the later development or rock'n'roll. Three jazzmen stand out: John Coltrane, Miles Davis, and Charlie Christian. All fed into the jazz rock style of Jimi Hendrix in the 60's.

Influenced by Ornette Coleman, and recording with Coleman's sidemen, John Coltrane developed a style of free jazz. This style later influenced 60's rock just as his earlier, more melodic style influenced jazz rock. Coltrane played for some time in the Miles Davis Band. After his departure, Wayne Shorter played sax for Davis, and later joined a jazz rock band called Weather Report. Weather Report played and recorded the Jimi Hendrix tune "Third Stone from the Sun." Thus there is a direct line from Coltrane to Davis to Shorter to Hendrix. In fact, Davis was to have recorded with Hendrix, but, because of Hendrix's death, Davis had to settle for recording with some of Hendrix's many followers in his performance of cool jazz.

Meanwhile, Coleman Hawkins had brought the tenor sax to the same position of prominence as a solo instrument played against a larger band as Louis Armstrong had with the trumpet. Lester Young, who played with Count Basie, brought improvisation to new levels of importance. His playing is at the roots of bop and modern jazz and was a style which had a lighter sound than that of Hawkins, being more directly oriented in linear melody.

41

Sessions held by these players at a spot called Minton's in Harlem, joined by Charlie Christian, Dizzy Gillespie, Theolonius Monk, and Charlie Parker took the music beyond the limits of swing and into jazz.

While Coltrane is important to free jazz, Miles Davis is important to cool, or modern jazz. Modern Jazz is essentially a combination of the styles of Louis Armstrong and his New Orleans swing music and the styles pioneered by Charlie Christian, Parker, and their friends who pioneered inprovisational bop music in the early 40's. Cool jazz, which is arranged music, developed a decade later, in the 50's, and is exemplified by Miles Davis and others who mellowed the sounds of hard bop. Out of the Davis experience came many important artists, the most important of which was John Coltrane himself.

The third important figure is Charlie Christian. As musicianship developed so did the guitar gradually rise to prominence. Christian, while in the Benny Goodman Band, had played an amplified guitar, thereby revolutionizing guitar playing. Les Paul, Dijango Reinhart and T-Bone Walker were all directly influenced by Christian. When Christian died in 1942, he left a gap in the pop music scene. With the exception of modern blues men, who did not record until the late 40's such as the Muddy Waters Band, Elmore James, B. B. King, and many more, and who did not reach the large white audience, the sax remained up front in the jump bands that generally replaced the big bands rather than being gradually replaced by the guitar. The importance of the guitar therefore hit a period of no growth following the death of Christian, the major proponent of the instrument.

The reason for this gap in the development of the guitar after Christian's death was a lack of understanding of the purpose of amplification on the part of musicians outside the blues tradition.

But there always was guitar activity. During
the 20's and 30's, music had already been made with
melodic guitar solos. Lonnie Johnson and Eddie
Lang, individually and on joint recordings, were the
leading developers of the guitar during the 20's.
Apart from their work, however, the problem of
volume was a difficult one for guitar musicians to
overcome in ensemble pieces, playing in unison with
a sax or trumpet.

While Eddie Durham was an early pioneer in
amplifying the acoustic guitar, the electric guitar
instrument as we know it today was developed by Les
Paul. He invented the solid body electric guitar,
and he also developed the technique of multi-track
recordings, which, together, brought guitar to pro-
minence. Charlie Christian's highly individualized
solo techniques were the prototypes of the music
that took advantage of these technological develop-
ments.

Christian, who was born in Dallas in 1919,
followed a long line of South and Southwest gui-
tarists who were influenced by Spanish styles and
the style of playing developed by slaves, who, since
they were not allowed drums or horns, had turned to
the guitar. Christian recognized the new difference
in sound the amplified guitar could make and the
implications of the sound. He saw that amplifica-
tion did not just make notes louder, but longer as
well. The potential to lengthen the notes made it
possible for him to develop a style which included
sustained legato lines similar to that produced by
the violin or clarinet.

Hendrix is of paramount importance to jazz rock.
His art was directly influenced by Coltrane and
Christian. Following the line of Christian, he
pioneered into new areas of electronic guitar
sounds. His use of wha wha pedals and other
distortion techniques enabled him to expand the
possibilities of sounds from the guitar to meet the
challenge of self- expression written into perfor-
mances because of the influence of Coltrane. In

43

his short career, he covered a range of music from basic blues, to rock, to jazz rock in a style that was a natural way for him to play. He produced sheets of sound which overwhelmed the senses of his audiences.

Further developments in jazz took place during the 60's. Coltrane's free jazz style reached a large audience through records, concerts and and blues and rock 'n' roll. His drummer, Elvin Jones, inspired every important hard rock drummer in the 60's, such as Ginger Baker of Cream, and Mitch Mitchell who played with Hendrix. He influenced every jazz man in a way Charlie Parker had before, revolutionizing music as much as Charlie Christian had.

Jazz was not the only form of music developing in America in the first half of the century. Other forms of music pushed by disc jockeys into popularity were the Latin sounds of Xavier Cugat and Prez Prado, their samba and tango music and more importantly, perhaps, boogie-woogie, an offshoot of jazz.

Pine Top Smith's "Boogie Woogie" was the first boogie-woogie hit, although Pete Johnson was the style's greatest practioner. Boogie-woogie was played using the left hand to develop a consistent pattern, while the right hand was free for improvisation.

During the period of the Second World War, the big bands lost some prominence because of a combination of developments. The musicians went on strike for a fund to be established from record company profits for the musicians. Record sales fell because of a war-induced shortage of shellac; and gasoline rationing cut down on travel, thereby keeping dancers at home; and a 20% amusement tax was levied at nightclubs and dance halls to finance the military. And tastes began to change.

44

As the Depression had fostered a mellow music, so did the war. People preferred bands playing sentimental ballads, backing a vocalist like Perry Como, and later the hot sensation of 1943, Frank Sinatra. Instrumental music, in short, gave way to vocal music. The big bands went out, the singers came in. Songs from musicals reached the top of the charts. In 1943, the album from the New York musical <u>Oklahoma!</u>, contained five of the top selling individual songs of the year.

In the late 1940's, while popular songs of the sentimental ballad tradition caught the ear of the majority of music listeners in America, there were developments in jazz-related music which spawned a new wave of American popular music. Rhythm and blues and country and western music increased in popularity. Each had its own stars and special audiences. A number of distinctive sounds, such as honky-tonk and blue grass, developed. Rhythm and blues, meanwhile, featured a saxaphone wailing against a rhythm section with a hard beat, or featured an emotional singer detailing the hurt of love and abandonment, or a mellow vocal group expressing romantic moods using imagery from nature.

Country music, influenced by jazz, had developed, since the 20's, a hybrid style in the Southwest known as Western swing. Bob Wills and the Texas Playboy's, Milton Brown and the Hi-Flyers, and Spade Cooley were among those who achieved fame with this unique sound.

These two separate traditions, rhythm and blues and country music, merged in the South to form a brand new sound, labeled rock 'n' roll by Alan Freed, a Cleveland disc jockey, who recognized the trend and rode it to fame himself. The subject matter of all these songs was the love and feelings and concerns of teen-agers, and derived from teen image rock poetry first created by Chuck Berry.

These lyrics were sung over a clean, clear, res-
trained guitar. These teen-agers had the money to
spend on the songs which told of their own romantic
trouble. The music featured a driving beat, com-
bining with lyrics of personalism and group iden-
tification.

Rock 'n' roll grew out of rhythm and blues,
which began picking up white listeners in the early
50's. In 1953, Freed began his Moondog Rock'n'Roll
show in Cleveland, moving to New York two years
later. Freed played black records for a black and
white audience, keeping time by pounding a telephone
book to the beat of the music, while on the air.
The term rock 'n' roll itself had appeared in black
records since the 30's, having mostly a sexual
connotation. The first rock'n'roll record is a
matter of conjecture although "Good Rockin Tonight,"
by Wynonie Harris in 1949 had all the ingredients of
what was to come a few years later.

Rock as a combination of rhythm and blues and
country music is exemplified by Bill Haley and the
Comets, Chuck Berry, and by Elvis Presley. Haley
directed a small, unsuccessful country and western
group; but he became better known when he blended
that style with rhythm and blues, and recorded
"Rock Around the Clock," which was used to score the
movie Blackboard Jungle, a film about a teen-age
rebellion in an urban high school.

During 1955, Chuck Berry, Ray Charles, Little
Richard, Bo Diddley, and Fats Domino had their
first hits, setting the trend for the remainder of
the decade.

Berry's guitar style combined white and black
country blues and boogie with the electric guitar
styles of Charlie Christian and T-Bone Walker. In
fact Berry even recorded Christian's "Flying Home."
Berry's popularity, however, was result of clever

46

white-related lyrics, often with sexual overtones, and his white sound. His influence was to reach out to Jimi Hendrix and other guitar heroes of the 60's and 70's who combined the spirit of Chuck Berry rock'n'roll and the more dissonant sound of Chicago blues.

By the late 1950's and early 1960's rock'n'roll had lost much of its early impact: Elvis was in the Army; Buddy Holly was dead; Chuck Berry was in jail; Jerry Lee Lewis, another star, had alienated the public by marrying his 13 year-old cousin. Younger performers, such as Frankie Avalon, Paul Anka, and Bobby Rydell were singing watered-down syrupy ballads; payola was rampant. But this was a period dominated by rocks' greatest performer, the king.

The King of Rock'n'Roll is Elvis Presley. Presley, born in Mississippi, was raised on country music, gospel songs, and black country blues. His songs featured romance against a driving beat; and, with his twisting torso, he featured sublimated sex in his performances. His appearance on the Ed Sullivan Show and the Steve Allen Show made nationwide impact. He switched recording companies for little Sun Records to giant RCA and became rock's first superstar. He paved the way for Carl Perkins, Jerry Lee Lewis, Buddy Holly and numerous other Southern boys, who sang country with a beat and achieved popularity.

New dances were shown to a whole nation of teen-agers on the television tube, the Twist, the Stroll, and the Shout. Also among them was a dance called the Mashed Potatoes, too; any old thing you wanted to do as long as you danced to the energetic music.

Late fifties and early sixties rock music was supplemented by a new interest in commercial folk songs, particularly on the college campuses across the country. Groups often took old folk ballads and

updated them with a more rhythmic banjo or guitar accompaniment than they were heard with in their inception. These folk groups wore then fashionable cassual clothes and appealed to notions of cleanliness and respect for the past. Top groups were the Kingston Trio, the Chad Mitchell Trio, Peter Paul and Mary; top soloists were Joan Baez and Judy Collins. These performers adapted songs by such artists as Woody Guthrie, Peter Seeger, Leadbelly, and Lightinin' Hopkins. As a result, young people took to playing guitars and banjos to create smooth, carefully rehearsed songs. Locally favorite groups of good quality were born and died yearly. While this music was from the folk tradition, it was not sung by native farmers or mountaineers or by other traditional types, but by song stylists wearing buttoned-down shirt collars. Their songs were about rivers, mountains, and towns, although performers made no pretense of being from these areas either in speech or in habit. The movement tended to homogenize regional musical differences. Many new writers, however, sprang up to augment such traditional but sterile styles, among them Bob Dylan. Dylan came to New York in 1961, and was influenced by Guthrie, among others. With the rise of political apprehension stemming from civil rights issues and later the Vietnam War, he, and others, were concerned with contemporary issues in protest of American tradition and politics. Dylan's "Blowing in the Wind," was made popular in a smoothed down version sung by Peter, Paul and Mary, a cover situation similar to that which made Bill Haley popular recording black music. It was the first social protest song to become a number one best seller.

Dylan went on to become the most significant writer of the 60's and 70's. Other writers who achieved varying degrees of fame durng this time were Tim Hardin, Leonard Cohen, Phil Ochs and Gordon Lightfoot.

Folk music declined in popularity after 1963 with the rise of the commercial success of English groups which revolutionized popular music in America. The Beatles' tour resulted in Beatlemania, riots, long hairstyles, and Edwardian clothing The Beatles mixed all the trends of popular music skillfully together -- ballads, folk music, fifties rock, and rhythm and blues, and particularly Chuck Berry material, with elements of good humor and fun. Their rivals, the Rolling Stones led by Mick Jagger, meanwhile, stayed within the bounds of rhythm and blues and were the outlaws of the rock music scene, associated as they were with sex and violence, as for example in their best selling hit "Satisfaction." The Stones were influenced by Muddy Waters and Chuck Berry and Chicago blues in general. The music of both of these groups, the Stones and the Beatles, led to a host of imitations and spawned a new generation of popular music.

Technological improvements in the recording industry, such as multitrack recordings, resulted in recorded music which could never be duplicated in a live performance. But the basics of the music remained the 4/4 beat played beneath a rolling melody. The adaption of these aspects of rock to folk music songs did not take long. The result, folk rock, sung by Dylan, Sonny and Cher, the Byrds, the Mamas and the Papas, and Buffalo Springfield, among others, represented a new synthesis of the previous band sounds. The music developed hordes of mainly white followers.

Meanwhile, the rhythm and blues tradition continued as the basis for mostly black music. Aretha Franklin, James Brown (the King of Soul), Ray Charles, Ike and Tina Turner, Sly and the Family Stone all produced hit after hit and won adherents among white listeners. More rock-oriented performances by such black groups as the Supremes and the Temptations bridged both audiences.

White music was influenced by the black man, Hendrix, playing for a white audience a loud amplified guitar dominated rock. He was part of a development which came to be called psychedelic music, and was meant to simulate drug experiences when permormed during light shows of colors and patterns in random motions projected on to walls in the auditorium simultaneously with the performance of the music. The rhythm and blues music of The Grateful Dead and the Jefferson Airplane of this type, associated with San Francisco, was widely popular. The music celebrated being high, or, occasionally, being low as in the Dead's song "Truckin -- Got My Chips Cashed In."

Rock music became harsh, frenzied and confussion-ridden, played by electric instruments heavily amplified; the bass, previously restricted to the basic chords, was played like a guitar or drum in varying rhythmic patterns. Instead of providing merely the beat, the drummer worked with the guitar and bass to create complex rhythmical petterns, which became material for extended solos. The most important instrument was, however, the electric guitar. It was fitted with new devices that extended the range of the instrument to the degree that sometimes its sound could not be recognized as coming from a guitar and its greatest practitioner was Jimi Hendrix.

While Hendrix is important in the development of jazz, he is likewise important in the development of rock. Besides the jazz relationships which exist between Hendrix, Coltrane, Davis and others, there is a strong rock influence on Hendrix, particularly from Chuck Berry, and also from Little Richard, whose band Hendrix had played in. Hendrix's pioneering use of the wha wha pedal, the wall of sound technique, the wild stage art in which he burned his guitar, are important for their influence on later artists. But most importantly Hendrix expanded the bounds of rock and jazz both, by combining them in new ways, particulary in "Purple Haze."

50

In August of 1969, the Woodstock Music and Art Fair was held on a farm in Woodstock, New York, in muddy rainy conditions, it was attended by 400,000 fans who came to listen to many of the most popular musicians play. Woodstock proved to be the high point and the end of the rock scene. Many of the groups broke up, and the music took various directions in the 70's as the Flower Children of the 60's with their rock festivals passed into adulthood.

The 70's was a decade when rock became more mellow, and the ear-splitting confusion of acid rock took on a sideshow quality featuring smashed guitars, snakes on stage, and performers dressed as ghoulish monsters. The music attracted an even younger audience of 12 to 14 year olds. In fact, such performances called glitter-rock pointed out a temporary dead end in the development of popular music. Remakes of previous hits by big name artists was another marker of the phenomenon of rock's decline. New groups, however, prospered with the more mellow tone consistent with the 70's rock style: the Eagles, and Jackson Browne relied on a confessional tone to their verse, backed by simple rhythms on guitar, to produce a sound within the tradition of rock.

While white rock was reaching millions in the early to mid 70's, black music took off into a new direction, bringing some white rockers with it. It used a steady beat; it was easy to dance to in new steps called the Hustle made popular by Van McCoy, and the Latin Hustle. The dances called for the dancer to know choreography and have the time for rehearsal with his partner before hitting the public dance floors of the disco bars. The songs of Donna Summer, Gloria Gaynor and others sometimes were merely disco-ized versions of old rock hits, but occasionally were new creations. These songs all offered their listeners a steady beat derived

51

from Jamaican reggae music, overlaid recording tracts for a sense of continuous music energy, and fairly simple lyrics. To many, disco was merely an updated, if simplified, remaking of Aretha Franklin's soul style into a narrower format. Meanwhile, black groups like Earth, Wind , and Fire continued the broad combinations of rhythm and blues jazz. They produced music with a basic, hard, driving rhythm overwhich a wall of sound from individual players cascaded à la Jimi Hendrix.

Among those who contributed the most musically in the 1970's were Frank Zappa, The Band, Van Morrison, the Allman Brothers Band, and Stevie Wonder. An examination of Morrison's work shows the background to the more mellow sound of the 70's.

Two Morrison songs in the 60's were strong influences on amateur local bands, who played them for millions of listeners. These two solid rock songs wer "Gloria" and "Here Comes the Night," neither of which was as popular saleswise as many of the Stones or Beatles songs of the same period. But both show a heavy blues influence, which was typical of the period.

In the late 60's and through the 70's Morrison sought to combine Celtic poetry and jazz. On albums such as Astral Week he employed first quality jazz musicians. On following albums he incorporated a personal style as well as the continuing use of the blues, rhythm and blues, and jazz traditions that are at the foundation of rock. A late 70's album, Wave Length, uses a synthesizer, the most important new instrument of the period, the electric guitar, and drums to form a totally new jazz rock sound.

Following the rise of white groups with mellow and traditional sounds, Punk Rock, imported from England, sought to revivify rock performance and

52

lyrics with themes of loneliness, violence, and
alienation. Wearing safety pins in their ears and
affecting rags for clothes, the likes of Sid Vicious
and Johnny Rotten and the Sex Pistols never
attracted crowds and advanced only to the cult stage
of recognition among American audiences.

American artists, however, received a positive
benefit from observing the excesses of these
groups-this New Wave. Of the best of these groups
is Blondie. Combining the steady beat of disco a la
Gloria Gaynor and Donna Summer, with the fire of
rock, and glamorous, sexy lead singer Deborah Harry,
their first album seemed to be a put on, perhaps of
straight music, perhaps of the New Wave itself. It
had songs like "Attack of the Giant Ants" and "Kung
Fu Girls," But Blondie changed thereafter under the
leadership of Ellie Greenwood, who developed into
popularity the all girl groups of the 60's, such as
the Crystals and the Ronettes. Later Blondie albums
have been more polished versions of their first
album's style. The sound is solid rock, but the
songs adapt the New Wave concerns about alienation
to an optimistic beat, the result being a new brand
of social consciousness. "Shayla," for example,
tells of a factory girl, drummed by daily routine,
who runs off down the road with her paycheck to be
met by "some cosmic energy," that others see only as
a flash of light. She has left the material world
of boredom, factories, and the reality of survival
against a background of a steady beat. "Slow
Motion" suggests that a person ought to stop
dreaming, look around, and experience what there is
of modern life. Yet it sounds like a happy Supremes
song of the 60's.

Blondie, then, puts the tradition of rock to
work, and confronts the issues of survival in the
industrialized world by using a revived style of
realism, blending the two trends of the late
seventies, realism and tradition techniques as they

53

were being blended by other artists in other forms at the time, most notably in painting, and also in sculpture.

Another form of American music, country music, became popular in the 50's growing gradually into the 60's until it merged with rock to produce folk rock. The late 60's and 70's saw country music become widely popular in both urban and rural areas.

Derived from the music played by the early settlers of the country who played folk tunes of English origin on violins and whatever instruments they had brought with them, country music songs were then, and continue to be now, about love, loneliness, labor issues, poverty, hard times, infidelity, drinking, trains, and death. They are played or sung by either male or female vocalists in a style of music developed in the rural areas along America's first frontiers in the Appalachian Mountains but then carried all over the country by pioneers seeking fame, fortune, or simply a better place to live. The fiddle, bass, guitar, and banjo are the main instruments the musicians used and still use to accompany the lyrics to these simple but emotional songs. The songs of Woody Guthrie, and others featured an accomplished playing style, and emotion-packed delivery, and succinct lyrics. Jimmie Rodgers and the Carter Family were the first stars of this kind of music.

They were followed by Roy Acuff, Uncle Dave Mason, the Delmore Brothers, Ernest Tubb, Hank Snow, and Sam and Kirk McGee.

Even while rock was important, country music picked up more and more and more listeners. The 1950's saw the rise of Hank Williams, country's most prolific writer. Bluegrass, which had developed in the 40's, hit its stride in the 50's. Bill Munroe, Flatt & Scruggs, and the Stanley Brothers developed

a sound which was successfully revived in the 70's.
Honky-tonk music, however, exemplified by the
efforts of Webb Pierce, Carl Smith, and Lefty
Frizzel was the main sounds of country and western
music in the 50's and 60's.

As country music grew into big business, its
capital became Nashville, Tennessee. Practitioners
of the style in the 70's, continued to write about
pain, betrayal, anger, and pride within the country
tradition. Kenny Rogers', "Don't Take Your Love to
Town" is an example of how country music remains
topical and traditional at the same time. The sone
is of a paralyzed Vietnam War veteran imploring his
wife not to leave him for better sex awaiting with
some stranger in town.

Another view of country music is the story song,
essentially derived from the medieval English format
of the ballad. It tells of events ranging from
football games to hostage taking, events ordinary
and extraordinary in the life of working people.
The best of the writers and singers of story songs
is Tom T. Hall. In a voice barely on key, Hall's
songs tell of the dramas which punctuate the lives
of the little poeple of American society, the truck
driver, the housewife, the dirt farmer. "Harper
Valley PTA," a tale of a mother and child rejected
by the small-minded Parent Teacher Association of
Harper Valley elementary school, and the mother
getting mad enough to "sock it to the Harper Valley
PTA," is an outstanding example of the essence of
country rock, and its storytelling mode.

Other country singers such as Hank Williams,
Kris Kristofferson, Waylon Jennings, Johnny Cash,
and Willie Nelson, and Dolly Parton, Crystal Gale,
Barbara Mandrell and Tammy Wynette write and sing
simple songs with emotion and simplicity, and
sometimes more than a hint of sexuality, in
capturing audiences who idea of the art music is
within the strict bounds of Americana.

55

Recommended Reading

Austin, William. *Music in the 20th Century, from Debussy through Stravinsky*. New York: W.W. Norton & Co., 1966.

Barzun, Jacques. *Music in American Life*. Garden City, N.Y.: Doubleday, 1956.

Bernstein, Leonard. *The Infinite Variety of Music*. New York: Simon and Schuster, 1959.

Bernstein, Leonard. *An Introduction to Music*. New York: Prentice-Hall, 1951.

Borroff, Edith. *Music in Europe and the United States: A History*. Englewood Cliffs, N.J.: Prentice-Hall, 1971.

Chase, Gilbert. *America's Music from the Pilgrims to the Present*. New York: McGraw-Hill Book Co., 1966.

Cope, David. *New Direction in Music*. Dubuque, Iowa: W. C. Brown Co., 1976.

Copland, Aaron. *What to Listen for in Music*. New York: New American Library, 1953.

Ewen, David. *Complete Book of the American Musical Theater*. New York: Holt, Rinehart & Winston, Inc., 1958.

Ewen, David. *Composers of Tomorrow's Music; A Technical Introduction to the Musical Avant-garde Movement*. New York: Dodd Mead, 1971.

Feather, Leonard G. *The Encyclopedia of Jazz in the Sixties*. New York: Horizon Press, 1966.

Goldstein, Richard. Goldstein's Greatest Hits:
A Book Mostly About Rock 'n' Roll. Englewood
Cliffs, N.J.: Prentice-Hall, 1970.

Grout, Donald Jay. A History of Western Music.
New York: W. W. Norton & Co., 1973.

Hansen, Peter S. An Introduction to Twentieth
Century Music. Boston: Allyn and Bacon,
1971.

Jones, Le Roi. Black Music. New York: W.
Morrow, 1967.

Jones, Le Roi. Blues People: Negro Music in
White America. New York: W. Morrow, 1963.

Machlis, Joseph. Introduction to Contemporary
Music. New York: W. W. Norton & Co., 1961.

Reis, Claire Raphael. Composers, Conductors,
and Critics. Detroit: Detroit Reprints in
Music, 1974.

Shelton, Robert. The Country Music Story; A
Picture History of Country and Western
Music. Indianapolis: Bobbs-Merrill Co.,
1966.

57

CHAPTER III

DRAMA

and

MUSICAL THEATER

A Brief Overview of American Drama

Of all the performing arts in America in the
twentieth century, the one that developed the
fastest, but not the furthest, is American drama.
A brief outline of the history of American dramas,
which follows, reveals that once realism became a
recognized and accepted style, little new deve-
loped to replace it.

At the beginning of the century, the theater
existed in five conditions.

1) Playwriting More playwrights were working
 than ever before, yet their
 products were second rate;
 150 new plays reached Broadway
 each year; farces, melodrama,
 romantic costume plays, senti-
 mental comedies, musical spec-
 tacles predominated.

2) Acting The classic repertory of comedy
 and tragedy was in decline; there-
 fore, performers from the emotional
 and personality schools, and the
 muscular schools took their place.
 Acting was at a low point.

3) Stagecraft Two dimensional painted scenery,
 with the exception of some realistic
 settings by Belasco, presented not a
 pretty picture to the audience.

4) Playhouses Thousands of playhouses followed
 the style of the Restoration play-
 houses -- proscenium arch, etc.
 There was little attempt to develop
 new styles.

59

5) Business Management Managers tried to mass-
 produce plays through
 theatrical syndicates.

Even though the staging of plays was at a low
point, playwriting was quickly developing. Ibsen,
Chekov, Stringberg, and Shaw began to write new
realistic plays, even before directors would
accept them. Generally, however, the United
States lagged behind the Theatre Libre' and Moscow
Art Theatre in productions of twentieth century
plays.

 In America, two people began the change to
styles that would be typical of twentieth century
American plays. Gordon Craig introduced two ideas
that were to take hold: 1) the one-man producer
for every aspect of the play and, 2) suggestive
scenery and lighting. Mrs. Fiske revolutionized
acting using a simple natural style, employing the
following aspects of the Modern School:

1) emphasis on psychological insight and truth-
 fulness in the portrayal of character;

2) concentration on inner feelings of the charac-
 ter with simplified and understated external
 action;

3) cultivation of a simple true-to-contemporary
 life manner of moving and speaking, in fact,
 an acting style of realism;

4) fidelity to the design of the play with all
 performers and effects subordinate to the
 overall purpose of the dramatist -- a concept
 called the Stanislavsky system.

In the period from 1920 to 1940 there were three special influences on theater: 1) World War I, 2) the Communist revolution in Russia, and 3) Freudian psychology. In the 1920's, Broadway had an international flavor: the plays mainly were from Europe and England, but also there were three types of native American productions: 1) musical reviews such as the Ziegfeld Follies, 2) Negro musicals such as the Darktown Follies, and 3) black and white combos, such as Show Boat by Ferber and Kern -- which was the forerunner of the "musical."

In the second decade of the century, American theater began to take steps toward modernism. The Theatre Guild was organized and dedicated to the production of fine plays in 1919. It established essentially a repertory system, with a new play produced each week by members of the Guild. The 1920-30 season offered 67 different productions, such as Eugene O'Neill's Strange Interlude, Marco Millions, and Dynamo, Sidney Howard's, The Silver Cord, and They Knew What They Wanted, Elmer Rice's, The Adding Machine, Ernest Lawson's Processional, S. N. Behrman's, The Second Man, and DuBose Heyward's, Porgy. The Guild broke up in 1938, however, when the main playwrights decided to go their own ways. In its day, however, the Theatre Guild brought realistic American plays to its audience, and gave the new realistic playwrights an opportunity to practice their craft.

Another repertory theater that followed the Guild with some success was Eva LaGallienne's Civic Repertory Theatre, which endured from 1926 to 1932.

Meanwhile, breakthroughs in new designs were led by Robert Edmond Jones, Lee Simonson, and Norman Bel Geddes. They used abstract sets with ramps, steps, plinths, terraced levels, light, costumes, masked actors, and portable props.

Two other occupational groups also became important in this period. Critics became influential in the 20's and 30's, among them Heywood Broun, John Mason Brown, Kenneth MacGowan, Burns Mantle, George Jean Nathan, and Stark Young. The director developed as a leader of the production, the most famous being Arthur Hopkins and Guthrie McClintic.

Meanwhile, in acting, psychological naturalism dominated, as played by the Barrymores, Alice Brady in The Silver Cord, Alla Nazimova in Anna Christie, the Lunts in Behrman's plays, Helen Hayes with the Theatre Guild, Katharine Cornell with Guthrie McClintic's productions, and Charles Gilpin and Paul Robeson in The Emperor Jones.

Later on, the Group Theatre led by Harold Clurman came to replace The Theatre Guild. During the Depression the Federal Theatre Project employed scores of theatrical personnel with various projects, such as the Living Newspaper. Through the good times and the bad of the 20's and 30's, however, New York groups did original plays.

Playwriting between the two world wars dealt with spiritual, moral, social and religous issues, and differing styles. Elmer Rice's expressionism, 1923 -- The Adding Machine, George Kaufman, Marc Connelly's fantasy -- The Green Pastures, Maxwell Anderson's poetic tragedies, Robert Sherwood's anti-war, Reunion in Vienna, Lillian Hellman's The Children's Hour, O'Neill's Mourning Becomes Electra, and Days Without End, Philip Barry's Philadelphia Story and Here Come the Clowns, S. N. Behrman's No Time for Comedy, and Thornton Wilder's, The Skin of Our Teeth show the range of America's playwrights during that period.

After World War II, the serious drama of Tennessee Williams, Arthur Miller, Edward Albee, and Neil Simon's comedies were the major attractions. A jumble of psychological realism, light-hearted

62

comedy, musicals, and the avant-garde combined with
reality, fantasy, sex, and violence to fill the
stage from the period of the 40's through the 70's

Because of the quantity of plays offered on the
American stage from O'Neill to the present, a look
into the major plays of only the most important
playwrights gives a view of the aspects of drama
which Americans, at their best, were able to develop
into high art.

O'Neill, himself, as the most significant figure
of American drama, was heavily indebted to the
European realistic dramas of August Strindberg and
also to models from the Greek classic dramas. In
fact, many of his plays are based on the Oresteian
cycle of plays by Aeschylus. Questions of social
and moral law are explored in O'Neill's plays, as
they are by Aeschylus; but in O'Neill's plays, the
hero is unsuccessful in dealing with these issues,
whereas in Aeschylus, the hero is successful.
Failure to O'Neill in the 20th century is a fit
theme for drama. August Strindberg, who dealt
heavily with love-hate complexes, and was the other
influence on O'Neill, is important because his kind
of influence gives depth of characterization to
O'Neill's hero -- a sensitive individual unable to
find a good ethic in an emotionally absorbing
circumstance. Most of O'Neill's plays demonstrate
either or both of these influences quite clearly.

The Iceman Cometh features a character, Hickey
who, while claiming that others must face reality,
has himself turned from it, having murdered a wife
he supposedly loved. But in so doing, Hickey feels
he has found peace. In Desire Under the Elms and
Beyond the Horizon, O'Neill uses the background
of New England Puritanism to highlight the frus-
tration of poetic individuals enslaved by that
very environment, while loving those who have
psysically enslaved them.

In many other plays, O'Neill resorted to practicing psychology on stage. The Great God Brown and The Emperor Jones show characters wearing masks as in Brown or being killed by silver bullets -- a talismanic projection of doomed immortality as in Jones.

Much of O'Neill's popularity and his influence developed from the persona he projected to the public. He was the misunderstood, brooding artist, concerned with the deepest of issues, haunted by a bad childhood, disease, and bad marriages; but he was handsome, somehow dignified and Olympian. In short, O'Neill himself was a great character for drama. Indeed, many of his best plays are in fact projections of his own life on the stage. Mourning Becomes Electra, combining the framework of a classical Greek play by Aeschylus and his own persona, is his greatest triumph. It consists of fourteen acts, lasts about eight hours, even longer than its companion piece Strange Interlude, and is the greatest fusion of Greek drama, Strindbergian expressionism and himself that O'Neill could conceive. While a monumental effort, however, it is, like O'Neill's other works, flawed by wordiness, inauthentic language, rambling, long speeches by the main characters, and a certain pretentiousness.

The career of Maxwell Anderson and, in particular, the productions of the stage version and the film version of one of his plays, Winterset, shows much about the workings of dramatic realism as well as the realism in its sister art, motion pictures.

Anderson, who was born in 1888 and died in 1977, was not just an institution of American theater, but a playwright of international stature. His works have been translated and produced in over a dozen non-English speaking countries. Importantly, Russia is

64

an exception, the reason being that the heroes in his plays speak for the American political values of liberty and justice for all when confronted with those desiring to enforce conformity, mob rule, or despotism.

He began his professional writing career as a newspaperman, as did America's greatest twentieth century realistic novelists, Hemingway and Fitzgerald. In collaboration with a book reviewer, Lawrence Stallings, Anderson wrote his first hit play, attacking the macho image of soldiers at war in What Price Glory? It followed the failure of his first play, also written in collaboration, entitled, Gods of the Lightning, which took as its theme the Sacco-Vanzetti case. Winterset, Anderson's greatest play is, similarly, concerned with Sacco-Vanzetti, a sort of second attempt at turning then contemporary issues into effective theater. Most of Anderson's later plays also deal with then contemporary events, although some, such as High Tor, were fantasy comedies written in verse.

Anderson, throughout his career, was prominently involved in theater history. He was a member of the Playwrights Company, along with other leading dramatists of the day including, Elmer Rice, Sidney Howard, S. N. Behrman, Robert Sherwood, and Robert Anderson. The group's purpose was to improve the art of American playwriting and theatrical production. The subsequent fame of these writers attests to their success.

Later in his career, Anderson turned his attentions to the film industry, which was experienceing mushrooming growth. He wrote the movie scripts for All Quiet on the Western Front, based on the novel by Erich Maria Remarque, and he adapted many of his own plays to the film media. Of greater success than others from this phase of his career, was Anderson's Anne of the Thousand Days, which starred Rex Harrison as Henry VIII.

65

<u>Winterset</u>, Anderson's greatest play, is about
the vengence of a son, Mio, against those persons
who had his father convicted and executed for a
crime he was innocent of, thereby clearing his
father's name. The sense of sorrow, loneliness, and
dedication that Mio brings to the task is riddled
with inner doubt and turmoil of conscience as he
encounters the gang of hoodlums and the erring judge
who were responsible for putting his father away.
The strength of his character is developed by the
threat to his loved one, Miriamne, who coinci-
dentally is the sister of a gang member brought by
the gang. He achieves measurable vengeance in his
discovery of the gang. But his love for Miriamne
prevents true revenge before he himself is executed
by the gang leader. Thus, the action of the play
demonstrates that his character has emerged to be
better, because of love and understanding, at the
end of the play, than it was at the beginning in the
tradition of classical tragedy.

Mio, then, is the hero of a modern twentieth
century American revenge tragedy, sharing many
qualities with the model for that type of hero,
Shakespeare's Hamlet. Unlike Hamlet, however, Mio
does not desire death for the offenders, but rather
a public acquittal of his father against all charges
brought by the errant system of American justice.
To heighten the drama of this relatively pacific
vengence, Anderson uses disreputable villains,
ghosts, and a succession of sensational scenes. He
creates a charged atmosphere, the most spectacular
instance of it being the re-appearance of the aptly
named Shadow in a scene which heightens the moral
tension of the play. The climax itself is tremen-
dously sensational, with Mio and his sweetheart
being machine-gunned to death.

That most of the language is in verse raises the
level of seriousness of the play, giving it a

poetic cast. The verse does not intrude on the action, as it is written in a style which approximates American speech patterns. Only at times is it perceivable as verse, and rarely does one attend to it merely because it is verse, thereby being distracted from the action. Nevertheless, the regularity of the verse is sufficiently different from the stops and starts, abruptness, and tonal fading of normal American colloquial speech that it does draw attention to how it is written rather than to what it communicates. This shift in attention is not a welcome one when it happens and therefore cannot be said to lend majesty to the action.

On the other hand, a play about the inner conflicts of man being resolved when the good in him conquers the evil is quite acceptable to the modern audience. Mio's becoming less hateful, more motivated by setting the record straight, demonstrates a developing moral excellence all but saintly in the desire to hand the members of the gang over to the authorities rather than to kill them. Mio's moral sense is so developed that, for example, in planning his own escape from the gang, he expresses fear that an old man, Esdros, may be injured in the effort. Finally, in the classical Greek mode, his discovery of the complete responsibility for the execution of his father is what ensures his own death.

The movie version differs significantly from the theater version. The difference epitomizes the difference between theatrical realism and movie realism. In the movie version of the climax, the hero does not die. Instead, Miriamne's brother is shot by another member of the gang. Then the leader of the gang is shot because of a mistaken signal. Mio and Miriamne are alive, happy, and healthy at the end. Good triumphs completely over evil, the good guys

living happily ever after. It certainly is not a
tragedy, but melodrama. Justice is served, however.

In the play version, the law is expected to
provide the vengeance against the killers. This is
quite a distinction from Hamlet, whose hero did his
own killing and reaped his own vengeance, before
dying at the end. Anderson expects that the modern
audience will confidently expect the criminal jus-
tice system to settle the issue. Twentieth century
American criminal justice, however, holds no such
promise for the contemporary audience. The
bail-bond system cannot exert tragic vengeance,
cannot exact classic justice because the law is no
longer final or absolute. So the conclusion of the
play version is equally as unsatisfying, ultimately,
as is the movie version, and neither is truly
realistic.

The two different versions suggest the
difficulty of finding a tragic ending for a play of
our modern society. No ending that could be chosen
is satisfactory, not even if everyone in Winterset
died. That would be totally unbelievable, because
in real life not everyone dies at the end of
anything.

In fact, other plays in which the hero dies at
the end also do not ring true -- Willy Loman's
suicide in Death of a Salesman among them. We
prefer to accept substitutions for death as being
more real, and therefore more tragic. The movie
version of Winterset approximates this with the
death of Garth, Miriamne's brother. He is a part of
Miriamne, and therefore "good" by association, and
his conscience is wracked by his role in the
execution of Mio's father, so he is an emerging
"good guy." His death is therefore, somewhat
tragic. His death is a manageable substitution for
the death of Mio, a price paid.

Clearly the difference in implication between
the endings of the stage version and the movie

68

version involve considerations of modern sensibilities. The play relies on a legal system to provide relative revenge, whereas the hero's dying, within the tragic tradition -- is an absolute event. In the movie, the death of the villains provides absolute revenge, with a part of the hero dying, (Garth) -- a relative event. The play version violates our contemporary tradition and understanding. The movie version violates the tradition of classical tragedy. It seems contemporary and classic ideas exclude each other in our society, making the writing a contemporary tragedy a dilemma. The dilemma is exemplified in Winterset and its two endings. The dilemma itself suggests that twentieth century America is a culture that will not admit tragedy; and suggests the differences between realism on the stage and realism on the screen.

Arthur Miller, whose career overlapped O'Neill's and Anderson's, dealt, with some exceptions, less with a personal vision like O'Neill than with an American socially conscious view. His most famous play, Death of a Salesman, tells the sad tale of Willy Loman, a failed salesman, who also feels he has failed as a husband and father. In fact, Willy has been crushed by the competitive system which he incorrectly believes brings the best out of all who work within it -- he is a man with the wrong dream. Critics have called this play a true twentieth century tragedy comparable to those written by the Greeks. But the play today suffers from a layer of sentimentality which was not noted in its period of popularity following World War II.

Basic to Death of A Salesman, is the father, Willy, trying to relate to his sons. All My Sons is another play by Miller which takes this theme and tries to show how fatherhood in a complex

69

society is a most difficult thing. This theme, derived from Homer, specifically the Telemachus theme, reveals Miller to be as deeply influenced by the Greeks as was O'Neill.

Where O'Neill and Anderson dealt with America's own history as a source of drama, namely the Puritan influence, so did Miller. Miller's play of this type, The Crucible, about the witch hunts of Salem, has, however, a sociological theme, dealing with emotionalism gaining control of reason. Written during the era of the McCarthy hearings, the play had a clear message to contemporary America.

Miller also dealt with himself as a fit subject for his plays, as did O'Neill. After The Fall tells of the agony and fulfillment which Miller experienced in his own life before, during, and after his marriage to the sex idol of the movies, Marilyn Monroe. Critics have found this play mawkish, as they have all O'Neills' personal dramas. The play is arresting all the same, even if it does depend on the audience's curiosity concerning two stars of its society attempting to deal with deeply personal emotions.

Another giant of the American stage is Tennessee Williams. A prolific playwright of uneven production, Williams, nevertheless, is responsible for some of America's greatest plays. In The Glass Menagerie, Williams uses four characters and one set, relying on moods created by lighting and language to tell a tender story of a crippled girl's failure to enter the adult world, while her brother, who has escaped the dull family circle, functions as a narrator. The play is poetic in all ways.

Ideally set behind a scrim, which is supposed to suggest that there is a dreamy side to the reality of action, the action takes place in the memory

of Tom Wingfield as he remembers an episode in the life of Laura, his younger sister. His mother, Amanda, tries to maintain decency for her family despite the poverty caused by her husband's abandonment. Laura is a shy, crippled girl who seeks solace with glass figurines. Tom finds her a suitor who abandons her, leaving her in a reality similar to that of the unicorn in her collection. The symbolism of the glass figures, particularly the unicorn as a figure for Laura, is enormously obvious. The pained guilt of Tom who had abandoned his family, as his father had days before him, is awkardly expressed as he stands to the side of the action. And the whole is roughly autobiographical. Thus the play is a combination of realism and theatrical tricks, which is passed off as "Realism." Yet, by any standard, it is a successful play, more artful than Williams' lusty, violent, later plays like Cat on A Hot Tin Roof, for example.

A Streetcar Named Desire exploits sex and violence to reveal the depths of insanity and vicioness in lower-class New Orleans. Stanley Kowalski's brutality is pitted against the make-believe world of his sister-in-law, Blanche DuBois. It ends up with him raping her, paving her way to the insane asylum. While Menagerie was a play of finesse, Streetcar is a play of power.

Some later Williams plays, Summer and Smoke, Cat on a Hot Tin Roof, Suddenly Last Summer, for example, deal with the desintegrating effects of emotionalism and violence, and as such, can be seen as a derivative of Streetcar.

A fifth important playwright of the twentieth century American stage is Edward Albee. The Zoo Story by Albee opened in Berlin and then swept into the United States in 1960. In this play Albee emphasizes the emptiness and sterility of

71

modern life. In terms of plot, it is the story of
the meeting of an upper class man and a lower class
man. They become friends, then argue, and
participate in a suicide-murder by means of a knife.
In conception, the play owes much to the movement in
world drama called "Theatre of the Absurd." Plays
of this type put lonely misunderstood common types
into a banal isolation. As the play unfolds, either
they or all around them proceed to go crazy or to
perform deeds which are irrational by the standards
of the audience.

Albee's second play, The Death of Bessie Smith,
tells of the death of the famous blues singer Bessie
Smith in the hospital after the automobile accident.
Quick changes of interest from character to charac-
ter highlight bigoted attitudes and demonstrate the
hopelessness of life.

Later Albee plays, The American Dream and
The Sandbox, explore dehumanized characters in
domestic settings by employing techniques similar to
those of the absurdist, Eugene Ionesco. These two
plays led the way to Albee's greatest success,
Who's Afraid of Virginia Woolf?

Woolf has a realistic plot dealing with a
college professor and his wife, the daughter of a
college president, who return home drunk from a
faculty party and are joined by another faculty
couple. The rest of the evening the professor and
the wife excoriate each other, reducing each other
to little more than drunken vegetables. Laced
throughout the play are references to a failed sex
life and failed careers as the basis for the mutual
verbal violence and destruction that they share. It
is a draining play to watch, but a play of such
intensity that later Albee's efforts have been, by
comparison, only disappointments.

Other playwrights, taking up the growing trend
toward examining the absurd condition of modern

society, have produced plays which are not quite as dramatically sound as those of Albee but arresting and memorable all the same. Among these is Arthur Kopit's Oh Dad, Poor Dad, Mamma's Hung You in the Closet, and I'm Feeling So Sad, subtitled "A Pseudo Classical Tragifarce in A Bastard Tradition." It was directed by the choreographer Jerome Robbins and is a play about sexual cannibalism. The Connection, by Jack Gelber, an off-Broadway production, is a "waiting" play, like that of many of the absurdists. Here, junkies wait for the connection who will supply them with their dope. The connection's name is iconographic -- Cowboy. The shooting up after he arrives is grating on the audience because it shows that the line separating the dope junkies from everyone else is a thin line.

Not all the best of the drama of the twentieth century is absurdist, however Howard Sackler's The Great White Hope is about the life of Jack Johnson, the first black heavyweight boxing champion. It is a play in the romantic tradition of the hero overcoming great odds to make good. Lorraine Hansberry's A Raisin in the Sun, similar in theme, explores the development of a black family in America. Both are examples of the rising importance of black art in the theater.

On the other side of the spectrum from serious social dramas, situation comedies have captured large audiences. The leading writer of these comedies, Neil Simon, has turned out hit after hit by putting a man and a woman, seemingly misfit for each other, in an enviroment where they cannot escape each other's company. They battle it out quite wittily, and finally fall in love. His plays do not challenge any of the audience's values, but provide consistent entertainment, such as in The Goodbye Girl. Because of the excruciating cost of mounting a play, a consistent money-maker is a virtual requirement for today's stage and situation comedies fit that prescription.

A History of American Drama

Modern American playwriting is really a
step-child of European parentage. The realistic
dramas of Henrik Ibsen, the symbolist plays of
August Stringberg, and the work of other European
writers leading to the development of modern drama
were slow to gain reception by American minds.
Prior to 1915, American theater was only lightly
influenced by developments on the Continent.
Americans preferred to have their plays deal
melodramatically with conventional issues, without
much "intruding" realism. The theater was a place
of escape to Americans, and plays a vehicle to
enchanted lands.

The career of James A. Herne at the turn of
the twentieth century represents the milieu of the
time. Herne, influenced by the tough realism of
Europe, presented privately, rather than commer-
cially, a realistic play, avoiding sensationalism,
Margaret Fleming (1891) that almost drove him to
bankruptcy because the public would not tolerate
it theme of illegitimacy. Having learned his
lesson, Herne's latter plays deal with
conventional subjects presented in soft realistic
detail.

William Gillette with Secret Service, (1895),
and William Vaughn Moody with The Great Divide,
(1906) and The Faith Healer, (1909) followed
Herne's experience, writing plays rife with
realistic detail in dialogue, setting and charac-
terization, in support of sentimental plots of
love and adventure. These plays were, at least,
successful in attracting audiences and making
aspects of realism, and thoughtful drama,
palatable to the theater-going public. Edward
Sheldon's Salvation Nell (1908) is a sign of the
times -- a play telling the story of a kitchen

74

helper who, in the service of the Salvation Army, transforms and wins a no-good lover over to marriage and conventional behavior. Sheldon's, The Nigger, 1909, and The Boss, 1913, seem to be hard hitting plays of the stuff of life, but their endings lead, unrealistically, to happiness for the principal characters.

American audiences are not totally to blame for the backwardness of American theater, however, for they themselves were being manipulated by booking agents and theater owners. Booking agents divided up the country, stamped out competition, and sent in plays of a conventional nature that were sure to appeal to mass audiences. In such a system, there was little opportunity for experimentation and development, little outlet for new talent and ideas. "The Syndicate," as it came to be called, in effect, controlled American audiences and American taste, and, therefore, American playwriting.

One of the few talents not to be managed out of popularity and existence was David Belasco, who produced a series of romantic plays but with a excruciatingly naturalistic stage setting. For example, in The Governor's Lady, (1912) the set is a child's restaurant, built in duplication of an existing restaurant, which served real food, cooked by a child, which real actors ate during every performance. Despite the Syndicate's attempts to buy him out, Belasco remained an independent competitor until he was able to strike a good deal in 1909. The Syndicate itself lost power in 1915, when its main force, Charles Frohman, died and was supplanted by the Shubert brothers, who remained supreme in booking road shows until 1956, when the government ordered them to divest their theaters to open up the competition to the free market place.

During the Syndicate's reign, there were some advances and some retreats in the development of

American theater. Ibsen's plays starred actors and
actresses of international fame for the effective-
ness of their realistic style, such as Alla Nazimova,
thereby broadening the American theater. At the
same time, however, Arnold Daly was prosecuted for
immorality, having produced George Bernard Shaw's
Mrs. Warren's Profession, which is concerned with
a prostitute.

After 1910, little theaters and the colleges
and universities gave playwrights a place to work
out the problems of the native realistic modern
drama. Most famous was George Pierce Baker's
class in playwriting at Radcliffe and Harvard,
attended by Eugene O'Neill, S. N. Behrman, Sidney
Howard, Robert Edmond Jones, and which had its
imitators at other colleges and universities
across America. Commercial theater, meanwhile,
lagged behind.

The year 1915 is significant because it marks
the founding of the Provincetown Players by a
group of vacationing artists who remodeled a wharf
into a theater, and then produced plays by O'Neill,
acquired a theater in New York and remained a
source of new ideas, talent, and directions until
1929. Similar to other little theater groups in
many respects, it differed because of its willing-
ness to stage the work of those who could find no
other outlet, and in that it discounted the
importance of the set itself. Its productions
became so popular that its original purpose became
undermined by creeping professionalism, and its
operation was closed for re-evaluation in 1922.
The next year it reorganized, its leadership
shifted to O'Neill, Robert Edmond Jones, and
Kenneth MacGowan, its productions were
professionalized and its repertory was expanded to
include the European playwrights previously
avoided by Broadway. The significance of the
P-town Players lies in the fact that they opened
America to new playwrights and new kinds of plays.

76

Two other significant groups came into being in 1915 as well, The Neighborhood Playhouse, and the Wahington Square Players, both of which also opened up American theater to new modes and methods, despite their difficulties with finances and personalities.

The disbanded Washington Square Players gave birth to the Theatre Guild whose intention was "to produce plays of artistic merit not ordinarily produced by the commercial managers." This meant producing plays of the expressionistic European style using unusual lighting, sets and dialogue to project the emotional life of the characters to the audience, written by such as Shaw, Pirandello, Gorky, Strindberg and Tolstoy, and by the American Elmer Rice, whose The Adding Machine, was a starkly expressionist drama. Over time the Guild came to have its own company of players, its own playhouses and its own plays -- in short it became a complete repertory company. Like the Province-town Players before, success led to changes: in this case, O'Neill's plays became so financially rewarding that repertory was dropped in favor of the long run. Thus, the Theatre Guild's power to change American drama was diluted. Despite the policy of long runs, the finances of the Guild suffered during the Depression, and it gradually became indistinguishable from the commercial producers it had earlier rebelled against.

Eva LaGallienne's Civic Repertory Company and Walter Hampden's companies, and the American Laboratory Theatre complemented the work of the Theatre Guild during this period in trying to bring the best of drama to American audiences. On Broadway, Arthur Hopkins produced with success plays written by Rice, others with sets designed by Robert Edmond Jones, occasionally expres-sionistic plays by German authors, and others starring the Barrymores. In Hopkins' plays, the text, the playwright's work, was emphasized over

77

set and acting, a new practice which gave vitality
to American theatre as other producers saw that
audiences would flock to a good play in greater
numbers than they would to plays having good
actors and good sets.

This is not to deny that the "new stagecraft"
undervalued actors and sets. Indeed, great names
of the theater emerged under this set-up because
their contributions were artistically unified to
the production as a whole. Norman Bel Geddes
brought set designers to high regard, Katherine
Hepburn and Clark Gable reached fame and brought
the actor's craft to a plateau; and Sidney Howard,
Philip Barry, George S. Kaufman, Robert Sherwood,
and Maxwell Anderson became successful playwrights
with Hopkins.

Much of the progress made during the 20's was
halted by the Depression. The Works Progress
Administration in 1935 funded the Federal Theatre
Project which put many theatrical people back to
work, fostering a regional theater system and
financing over 1200 productions of 830 works. It
was stopped in 1939 by Congress' failure to appro-
priate money to a project deemed too "liberal."
Best known of the projects stemming from the
Federal Theatre was the living newspaper series,
which explored then contemporary social problems,
and written by various authors. Perhaps most
famous was the Power, (1937) segment which looked
into the TVA project and the electric companies,
using newspaper articles and public documents as
source materials.

An outgrowth of the Federal Theatre projects
was John Houseman's and Orson Welles' Mercury
Theatre, which fostered black involvement in
American theater, and stimulated all manner of
plays dealing with social issues, particularly
"workers theatre" concerned with labor/management,
capitalist/socialist questions. The advent of

better times, however, as the country recovered
from the Depression, tended to render these kinds
of plays passe'. Furthermore, other forms of
entertainment, such as film, took away audiences
and whatever hope of profitability producers had
in a period of rising production costs and
spiralling overhead.

In response to these pressures, and to insure
the staging of their own works, Anderson, Rice,
Howard, Sherwood, and Behrman banded together to
produce their own and other writers' plays as the
Playwrights Theatre in 1938, remaining a major
producer until 1960. Sherwood's <u>Abe Lincoln in
Illinois</u> and Behrman's, <u>No Time for Comedy</u> were
among its better productions before World War II.

In general, between World War I and World War
II, American playwrights dealt with new themes and
techniques on a broad plane, although they
pioneered new ground in neither theme nor tech-
nique. Still the adaption of European styles and
themes resulted in a high point of American drama,
a point which has not been reached since.

Anderson, Clifford Odets, and Lillian Hellman,
all had plays which were important on the stage
after World War II. They were joined by Tennessee
Williams, Arthur Miller and William Inge (<u>Picnic,
Bus Stop</u>) all of whom offered a vein of realism
which was really not real but instead a kind of
theatrical realism, in which the symbols and
certain speeches contain nuggets of super-reality,
of Truth, and the rest of the play is realistic
only in so far as it need be. Particularly, the
stylization of sets and minor characters is meant
to reflect the values, either positively or
negatively, of the playwright.

<u>The Glass Menagerie</u> by Tennessee Williams is
an example. Written in 1945, it was enormously

popular, and it continues to be shown upon the
stages of theater groups, colleges and universi-
ties.

One of William's plays brought to public
consciousness the acting of Marlon Brando, and a
new realistic, powerful acting method. Derived
from the system of the Russian Stanislavsky,
developed in America by the Group Theatre and
popularized through the Actors Studio by Lee
Strasberg, the method was one in which actors
sought to liberate themselves from the constric-
tions of their roles by emphasizing emotiveness,
improvisation and the identification with the
character being played. Called "the method," this
technique was employed by Brando as Stanley
Kowalski in Williams' A Streetcar Named Desire in
a role in which the animation he brought to the
character was emphasized by his psychological
energy and brought a strong sense of realism to
the performance.

Despite its detractors, the Actors Studio
became more famous and powerful through the
popularity of this technique, waning only when the
style of psychologically powerful heroes started
to fade before the rise of plays in the 60's with
self-analytical heroes.

The flush times of the 50's and 60's resulted
in a diversification of theaters. More off-Broad-
way houses opened. The American National Theatre
Academy attempted to provide a showcase for re-
gional companies. Dinner theater became a popular
pastime. But ever escalating staging costs
limited the plays presented every by these groups
to those featuring little experimentation, in
favor of those of the more tried and true types.

However, festivals of all sorts have added to
the diversity of American theaters, even though
there is some tendencey for them to be con-
servative in their offering. The New York

Shakespeare Festival is just one example. It happens to feature Shakespeare in Central Park, New York, but, led by producer Joseph Papp, then it took some of the productions on tour for the edification of the provincials.

During the 60's off-Broadway groups have come and gone with meteoric speed, and sponsored hundreds of plays by scores of playwrights that rightfully remain unknown. A large exception is, however, the work of black playwrights and their well-received and popular plays, among them Lorraine Hansberry's A Raisin in the Sun, and Le Roi Jones' The Toilet, which in completely different tones deal with the role of blacks in America's white-dominated society, a theme similar to that of James Baldwin's classic, Blues for Mister Charlie.

In general, through the 60's and the 70's two distinct approaches to theater existed, and, then, during the late 70's merged. The first of these is realism, which has such a long and honorable history on American stages. The second approach, one related to the general loosening of restraints brought out in the 60's in theater, as well as elsewhere, is the rise of non-verbal improvisational theater, a post avant-garde, post absurdist movement. The merging of the two in American theater brings, as a result, a new kind of realism which contains strong amounts of expressionism. The theater of various European countries during this period shows similar direction. Thus European theater has again become a source of influence on American theater, making drama international in style.

In this style, parody, burlesque, vulgarity, gags both visual and verbal, and violence, heighten the tension above that gained by the realistic presentation of much of the rest of the play. The style bears similarity to that found in painting decades earlier.

81

In America the plays of David Mamet, particularly Sexual Perversity in Chicago (1973) and Squirrel (1974) and David Rabe with Sticks and Bones (1972) and Streamers (1971) and Sam Shepard in Chicago and The Tooth Crime (1974) all show the influence of the international trend to blend expressionism and realism. These plays all take advantage of the break-up of conventions in language and performance, which began in the 60's, to create new areas in dramatic action.

Of great influence in this recent change have been several small theater groups such as Richard Scheckner's Performance Group, Cafe La Mama, Mabou Mimes, Richard Dorman's hoopla, and the Bread and Puppet Theatre.

An example of a realist-expressionist play is Cops written by Terry Curtis Fox, the first production of The Performance Group, which played in 1978. The action is set in a Chicago all-night luncheonette, recreated from working luncheonette to make as realistic a setting as possible. Real food is served during the performance.

The action consists of a series of arguments, discussions, and food ordered and eaten by patrons of the diner and three cops who are goofing-off from patroling, sitting in the diner. The dialogue is quite ordinary, quite real. In the process of telling about one of his investigations, one cop is shot by a customer who misunderstands a part of the story to be an order to surrender. Another cop mistakenly shoots the waitress. A hostage is taken, but then the killer is murdered by the third cop to whom he has surrendered. The end of the play shows the hostage in agreement with the cop on not saying anything about the murder. The expressionistic use of random violence and the realism combine here to create a powerful vignette of urban life.

82

While playwriting has developed into a post-realistic phase combining technical elements of expressionism with realism, as ode dia painting in the 60's and 70's, theater has likewise developed in a manner similar to that of the painting industry.

Painters, museums, and galleries all benefited during the 70's from a surge of enthusiasm, and a fresh injection of money, from collectors and agencies of the United States Government, particularly the National Endowment for the Arts and the National Endowment for the Humanties. The result was a proliferation of artists increasingly supported not only by public funds but also by private foundations. Similarly grants from NEA and NEH and private foundations to regional theaters, university theaters, and to playwrights themselves have brought drama to a high level of visibility throughout the country. New York is no longer considered the "only" place to play.

Instead, regional theaters such as the Mark Taper Forum, the American Place Theatre, Joseph Papp's Public Theatre, the Long Wharf, have all gained recognition as first quality institutions.

The large universities, for example Princeton University, have developed enormously popular seasons, drawing full houses of people coming to see not only the revival of older, respected plays, but also the efforts of new, relatively obscure dramatists as well. The effect is to give encouragement, and an outlet for the new American playwrights. Additionally, many universities have developed playwright-in-residence programs, many supported by NEA, that have been responsible for the production of many new plays. This movement, the launching of dramatic efforts by tens of the largest and best universities in America, shall prove more important than George Pierce Baker's workshop at Harvard which spawned O'Neill and many of the other stalwarts of American theater.

Musical Theater

One of the most popular of the forms of per-performing arts in America has been musical theater. It reflects various aspects of America's culture and combines other performing arts to reveal much about the changing tastes and aesthetics of Americans.

Beginning with the minstrel shows, the form of what was to become musical theater, audiences were captivated by the humor, the pageantry and the lyricism of this hybrid stage performance. These shows featured white men, wearing black faces of shoe polish or burnt cork, made up in imitation of Negroes, but rarely featured Negroes themselves. The effect was to depersonalize and stereotype the image of the black man, his folklore and roots on the plantation. The shows shared certain elements such an banjo playing, tambourines, cascades of songs, and dances and jokes. Much of the time between acts was given over to comedy dialogue between men in black face, called Mr. Bones and Mr. Tambo, and a middlemen, called Mr. Inter-locutor, who generally made the other two the butt of predictable jokes, such as for example, the old standby, "Why did the chicken cross the road?". Stephen Foster's songs were a staple of the musical entertainment offered: "My Old Kentucky Home," "Jeannie With the Light Brown Hair," and most famous of all, "Camptown Races," were regular features of ministrel shows.

Meanwhile, other forms of musical theater drew raucous, most male crowds to performances of all conceivable forms involving music and dance, not necessarily up to the minstrel level of artistic quality. For example, over three thousand cus-tomers showed up to see the debut of the sultry dancer Lola Montez, but only thirty patrons were women.

The first musical hit in New York was The Black Crook performed at Niblo's, one of the few legitimate stages available during 1866; and even that house had to be enlarged for the performance which lasted through five and a half hours of wandering plot. What made it a hit was that over one hundred chorus girls exposed more skin than had been seen before. Of course, bad publicity concerning the onstage carousing of the girls in scanty costumes only served to make the audience lines longer, the interest longer lasting. It ran 474 performances.

During the latter half of the nineteenth century developed vaudeville, dancing girl shows in saloons, and a few comedies using music with plots. Tony Pastor's music hall, which opened in 1864, attracted families with entertainment "clean" enough for women and was the starting place for such as Ned Harrigan and Tony Hart, comedians who later became the first producers to employ Negro performers in place of whites in black face. Their farces produced comedy based on whimsical exaggerations of Irish and German adaptations to America. Charles Hoyt refined this formula into a series of "comedies with music," most success- fully in A Trip to Chinatown starring Allene Crater and featuring the song "The Bowery." Similar to Harrigan and Hart was the comedy team of Weber and Fields, which employed German dialect and slapstick humor, then called Dutch-knockabout humor.

Between 1855 and 1900, the stars of operettas and musical shows became the toast of Broadway, providing New York with such legendary figures as Lillian Russell, who was to be seen with Diamond Jim Brady; Florenz Ziegfeld and his wife with the eighteen inch waistline, Anna Held; Charles Dana Gibson and his Gibson girls; and the Floradora Girls, who were made famous by one scene in the

play Floradora which featured the six of them
parading on stage with parasols to be joined by
six handsome men singing "Tell Me, Pretty Maiden."
That scene drew encore after encore.

In the early 1900's, Victor Herbert, con-
sidered the first American composer for the
musical theater, had a string of hits, The
Fortune Teller, Mlle. Modiste, The Red Mill, and
Naughty Marietta, which featured the "Italian Street
Song." Another important composer of the period was
George M. Cohan, trained in vaudeville, and who, un-
like others, was not so heavily influenced by Euro-
pean theatrical traditions. It is because of this
difference that Cohan is the more widely remembered
today, as he combined Broadway flair with American
patriotism in a mixture of vulgarity and sentimen-
tality. He wrote, directed, and acted in Little
John Jones, which featured "Yankee Doodle Dandy,"
and in You're a Grand Old Flag, a story about a
jockey riding in the English Derby.

Meanwhile, of course, audiences were still drawn
to the big production shows, at lavish theaters like
the Hippodrome, the largest, safest, costiliest play-
house in the world. European revivals like The Merry
Widow led to crazes of all sorts. "The Merry Widow
Waltz" is given credit for being the starting point
for the ballroom dancing craze which was to endure for
years.

From 1907 to 1931, Florenz Ziegfeld, and his
Ziegfeld Follies, musical reviews with scores of
dancing girls, broke the convention of the chorus
line by putting dancers in smashing costumes and
spectacular sets. The Follies, in turn, was the
launching pad for such stars as Fannie Brice,
Billie Burke, and Marion Davies, as well as Eddie
Cantor, W. C. Fields, Will Rogers, and Irving
Berlin.

With all this activity, vaudeville still cap-
tivated a significant percentage of those going

to musicals, mainly because it offered something
for everyone: animal acts, jugglers, acrobats,
song and dance acts, magicians, and comedians, and
featured some of the most popular stars America
had to offer: Sophie Tucker, Harry Houdini,
Gallagher and Shean, Nora Bayer singing "Shine on
Harvest Moon," and George Burns.

All this changed rapidly upon the outbreak of
World War I in Europe. Pro-American, anti-German
productions became the rage, and, in fact,
expanded and deepended the quality of American
musical theater. An example is Watch Your Step,
which starred the ballroom duo of Vernon and Irene
Castle dancing to Irving Berlin's syncopated jazz
rhythms. Less daring, but still artistic, were
the musicals of Jerome Kern, who teamed with Guy
Bolton and P. G. Wodehouse to produce plays with
small casts, simple scenes and American themes and
characters for the 299 seat Princess Theater. Not
to be out done by Kern's "Oh, Boy!" and "Oh, Lady!
Lady!" Berlin wrote the famous song "Over There,"
later to receive a Congressional medal for it, and
he contributed "Oh! How I Hate to Get Up in the
Morning" for a service show.

The differences between Irving Berlin's,
Watch Your Step, and Jerome Kern's plays became,
after World War I, the two distinct streams that
were American musical theaters: the one with jazz
rhythms, the other with lyrical style and American
themes. Of the latter type, the shows Irene and
Sally by Victor Herbert and Jerome Kern, featuring
"Look For the Silver Lining," and George M.
Cohan's Mary were finally combined into the show
Sally, Irene, and Mary. It played opposite
Shuffle Along, which was brought uptown from Harlem
and featured "I'm Just Wild About Harry," and the
all-Negro Runnin' Wild, with music by James P.
Johnson, which brought forth the remarkable dance
craze "The Charleston." In 1924, George Gershwin,
borrowing from the black tradition, wrote a show

87

for Fred and Adele Astair called Lady Be Good, bringing jazz dancing into popularity with such as "Pickin Cotton," "The Varsity Drag," and "The Black Bottom."

Meanwhile, once again the revue kept pace, Ziegfeld's Follies was joined by George White's Scandals, Earl Carroll's Vanities, and shows which were vehicles for multi-talented stars who would change the show in mid-act to suit their own artistic demands. Most notable was Al Jolson, whose songs often were outside of any show context but were the centers of the shows anyway. "April Showers" and "Toot, Toot, Tootsie" were made famous in this manner. The operetta, a form of American story set to music, featured songs like "Indian Love Call," "The Vagabond King," and "The Desert Song." The operetta The Student Prince used "Student's Marching Song" and "The Drinking Song" which are still widely know.

A significant shift in the manner of musical theater took place in 1927, with the production of Show Boat. Based on the novel by Edna Ferber about the hard life of the Southern Negro, with music by Jerome Kern and Oscar Hammerstein, it was the all-time Broadway smash. A literate, thematically serious show, it featured songs which are unforgettable: "Old Man River," and "Why Do I Love You." It opened up serious subject matter to the musical theater, a practice followed in such widely divergent works as Gershwin's Strike Up The Band, 1930, about war and money, Ira and George Gershwin, Morris Ryskind and George S. Kaufman's Of Thee I Sing, about national politics, and Gershwin's Porgy and Bess, an American folk piece of poverty and prejudice in the South. Pins and Needles by the International Ladies Garment Workers Union ran for three years, a propagandistic pro-labor play. Serious musicals were seen as important sources of social truth. The Federal Theatre Project's, The Cradle Will Rock about social protest, when canceled by the

government, was produced on a bare stage, its music accompanied by Marc Blitzstein, the composer, on piano. It was then privately financed after the government bailed out in fear of controversy.

Of course, not all the popular shows dealt with social issues. Kern's Roberta ("Smoke Gets in Your Eyes"), Cole Porters's Anything Goes, Billy Rose's Jumbo, with circus acts, and Rodgers and Hart's Babes in Arms were all without serious thematic content but featured good production and good music.

Picking up strains of both of these traditions, the thematic and the lyrical, American musical theater, came of age in the 1940's, combining plot, theme, lyrics, dancing set design, costume, and orchestration into a performing art. The years are filled with examples of great shows such as Pal Joey; written by John O'Hara, music by Rodgers and Hart, featuring "Bewitched, Bothered and Bewildered," and a story about a shiftless denizen of second rate nightclubs who finally makes good. Oklahoma! by Rodgers and Hammerstein opened in 1943, to become one of the longest running shows of all time; its songs hit the top of the charts, its ballet, choreographed by Agnes deMille, was historic because it was part of the character and plot development. South Pacific, adapted from James Michener's Tales of the South Pacific, a story of sailors on a South Sea island in World War II, had multiple plots concerning class consciousness, and used a new mode of sets. The stage setting was an objective representation but suggestive of moods and places.

In the 1950's the trend of shows getting better than ever continued. Guys and Dolls featured real-life New York. The King and I featured make-believe Bangkok, realistically presented. There was My Fair Lady in 1956, adapted from Pygmalion by George Bernard Shaw,

music by Frederick Loewe and Alan Jay Lerner, a story of the transformation of a England cockney flower girl into a lady at the direction of Professor Henry Higgins. It featured such songs as "I Could Have Danced All Night" and "Get Me To the Church On Time," and "On The Street Were You Live." West Side Story, in 1957, elevated dance to a most significant place in the production, as it transferred Shakespeare's Romeo and Juliet to New York's city streets. Its music was by Leonard Bernstein.

The 60's found The Sound of Music and Hello Dolly! the biggest shows. Dolly had a series of casts, starting in the beginning with Carol Channing, and then changing a number of times, on its long run, to Pearl Bailey. Fiddler on the Roof, Cabaret, Man of La Mancha, The Fantasticks, and finally Hair were the most popular musicals. The last three of these began at small off-Broadway theaters and then moved up to Broadway and finally generated road companies that toured to adoring crowds all over the United States.

The 70's were essentially a continuation of these musical traditions. Black musicals such as The Wiz, have, however, gained for the theater an entirely new audience. In a sense then, during the seventies musical theater had returned to its source of tradition, the minstrel show. But it had a new updated, upbeat face. Sentimental songs of the farm had given way to the omnipresence of rock 'n' roll and its heavy beat. It seemed to many that blacks could do this sort of show with style and verse that was impossible for white actors to generate. Musical theater had gone back to its tradition, and, because done by blacks, had achieved a new realism.

In terms of the number of productions of musicals and the numbers of people who attend them, the dinner theaters of the 70's had no

90

equal. The late 60's and 70's have seen a phenomenal rise in their popularity. As the seventies draw to a close, in a given metropolitan area a choice of musicals available to the public can number between five and twenty-five or more. For example, I Do, I Do, My Fair Lady, Hello Dolly!, King and I, were all available in Washington, D. C., at the close of 1979, all of them, for the ease of those attending them, located at surburban sites. This trend can be expected to continue into the eighties.

Recommended Reading

Bermel, Albert. Contradictory Characters: An the Modern Theatre. Syracuse: Dutton, 1973.

Bockett, O. and, R. Findlay. Century of Innovation A History of European and American Theater and Drama 1870-1970. Englewood Cliffs: Prentice-Hall, Inc., 1973.

Brustein, Robert. The Theater of Revolt: An Approach to the Modern Drama. Boston: Little Brown and Co., 1964.

Esslin, Martin. Reflections: Essays on Modern Theater. Garden City: Doubleday and Company, Inc., 1969.

Gessner, John. The Theater in Our Times. New York: McGraw-Hill, 1959.

Hewitt, Barnard Wolcott. Theater USA 1668 to 1957. New York: McGraw-Hill, 1959.

Kernan, Alvin. The Modern American Theater: A Collection of Critical Essays. Englewood Cliffs: Prentice Hall, Inc., 1967

Kirby, Michael, ed. The New Theater: Performance Documentation. New York: University Press, 1974.

Lumley, Frederick. New Trends in Twentieth Century Drama. Oxford: University Press, 1972.

Wellwarth, George E. The Theater of Protest and Pradox. New York: University Press, 1964.

CHAPTER IV

MOTION PICTURES

Motion pictures are artistic efforts totally new to the twentieth century and dominated by the contributions of American producers, directors, technicians, and actors. Many of the advances in the field of cinema have been technological ones developed both in America and abroad which have had a direct effect on the very nature of film as an art form. Furthermore, film has been most responsible to sociological pressure in this country and provides a mirror, if not an entirely accurate one, of the values of a broad class of American audiences different from that, in many cases, of the limited few interested in painting, sculpture, and ballet.

Film has had world wide popularity for about eighty years; and many of its early works are shown and enjoyed today, as are the classics in other art forms. In fact, the American Film Institute and many libraries and museums are actively engaged in preserving these early treasures so that coming generations may enjoy them.

Film art dates from a series of inventions at least indirectly related to Thomas A. Edison. After Edison had invented the phonograph in 1876, one of his assistants, Laurie Dickson, devised a method of putting together a series of still pictures to simulate motion. Edison, taking this idea further, created what he called a kinetoscope, which consisted of two spools that revolved in a cabinet, creating an automatic simulation of motion by figures on very small pictures. Eventually recognizing its commercial possibilities, Edison equipped it with a mechanism which tripped it into action when a nickel was deposited in it -- the hand-cranked nickelodeon was born. It was finally marketed, in 1892, to the penny arcades and later to kinetoscope parlors, and advertised by posters of stills of film then showing in the

parlors. In order to provide films for his
inventions, Edison built a studio out of wood and
tar paper which revolved so that his camera, or
kinetograph, could use natural sunlight for
shooting. The studio, called The Black Maria, and
the camera, which weighed almost 2000 pounds,
churned out one minute film after one minute film
on 50 foot reels.

During this period, Thomas Armat invented the
vitascope, the forerunner of today's projector,
saving audiences from squatting and looking
through the peepholes of the nickelodeon. Armat
then joined Edison in combining the vitascope and
the kinetosocpe, thrilling audiences in the movie
houses of 1896 with motion pictures. Edison's
company, and others which were set up in com-
petition, produced numerous movies about love,
magic, current events, as well as comedies, using
non-union actors who also had to do all the studio
dirty-work.

When vaudeville performers unionized at the
turn of the century and went on strike for higher
wages, the public turned towards movies for
entertainment. Later, with the strike over,
entrepeneurs bought up much of the equipment
vaudeville theaters had used to break the strike
and set up motion picture houses which flourished
in empty stores.

Over a brief period, when commerce saw the
advertising possibilities of these theaters,
movies became more and more respectable, and the
public became more and more desirous of seeing
even better stories. George Melies, a Frenchborn
director, filled the void by producing the first
film with a complete plot, Cinderella (1899). His
films came complete with all the tricks of the
cameraman's trade -- unusual camera angles, slow
motion, and dissolves. He became the king of the

chillers, movies of horror, emphasizing grotesque make-up worn by actors playing monsters of all sorts. His A Trip to the Moon (1902) was the first narrative film which took advantage of the potential of the medium with the use of a range of cinema techniques.

Edison and his company were not standing still, however; they added to the repertory of film by relying heavily on melodrama and new editing techniques. One such technique was Edwin Porter's idea of cross-cutting, to better present shifts in space and time, introduced in an American film, The Life of an American Fireman (1902). James Williamson, an Englishman, had invented the technique earlier; however, American producers also saw literary works as capitivating vehicles. The result was films such as Uncle Tom's Cabin (1903) and Ben Hur (1907).

But neither changes and improvements of subject matter nor technique influenced audiences as much as the stars. When Florence Laurence became a sensation as "The Biograph Girl" all film companies heavily plugged their stars, and continued to make money.

Edison, meanwhile, who controlled the motion picture patents, and his General Film Company had a monopoly on producing films in the United States, England, and France, as well as the distribution and exhibition of these films. The company extorted two dollars a week for a license to exhibit from all theaters, which in turn were restricted to showing Edison General films.

To circumvent Edison's hold on the industry, Carl Laemmle and William Fox organized the independent producers. They attempted to avoid Edison's restrictions by duping negatives and releasing the prints under their own logos.

Biograph, an Edison company, in an attempt to control the erosion of their profits from these "Pirates," put an AB, on each frame. Lawsuits which ensued became largely moot when Laemmle and Fox led the independents to set up new studios in Southern California, close to the Mexican border, for easy flight should they be raided. It was only after these independents had gobbled up large chunks of the market with their larger and better produced films that Edison's company was determined by the courts to be a monopoly and ordered abolished. With the West Coast a hotbed, the famous stars took their talents to California. Among them were Tom Mix, Mary Pickford and director D. W. Griffith and his cameraman Billy Bitzer.

It should be noted that actors were not at first so important. In the early years they were anonymous, and helped set up the sets. Later they were identified; for example, "Little Mary" was Mary Pickford. "The Biograph Girl," Florence Laurence, became the first big star when Carl Laemmle hired her away from Biograph and used her name to advertise his pictures.

Griffith's work became the standard by which others were measured. He changed camera positions in mid-scene, cut down the large gestures of theater actors to the level of significant facial expression to take advantage of the close-up, and gave a final sentimental touch with the last fadeout. Nevertheless, he was limited to making twenty minute films while the films of others were running twice as long because of licensing agreements. Another threat to Griffith and those imitating his style was the temporary popularity of film plays such as Queen Elizabeth (1912) and the Count of Monte Cristo in 1913. But Griffith's work prevailed as a standard of excellence.

Like Edison, Griffith did not so much invent new cinematic methods, with perhaps the exception

of the flashback, as he did use the techniques of others to heighten the drama of his film. In effect, his giving the camera an active role, and allowing the drama of presentation to determine the techniques used and the method of editing, are the bases for the art of the motion picture, an art completely different from theater-on-film, such as that of Queen Elizabeth, for example.

Griffith's reputation rests on two classic films, The Birth of a Nation (1915) and Intolerance (1916). Birth is the most influential film in history. It revealed that motion pictures could be strong agents of propaganda. It was the first political film, fueling nationwide controversy over its subject, the Ku Klux Klan, raising the issue of film censorship, and becoming the source of riots in Boston. It was, in short, the film which marked the beginning of the influence of mass communications in America. Furthermore, Birth was the film that gave cinema a place as a twentieth century art form. Intolerance, which followed Birth by some years, gave the widest play possible to the cinematic techniques which are the painter's brush strokes of the medium. The combination of pictorial scene, the rhythmic shifting of scene to scene, the effects of lighting and camera and narrative taken together in this masterpiece brought film, after only a comparatively short period of development, to a mature level.

After World War I the movie craze crested again, featuring a new element in movies for the general public, one which to this point had only been suggested -- sex. The high priest of the new style was Cecil B. DeMille, whose movies included beautiful women, handsome men, wild parties, sentimentality, and skin. The skin was presented in bathroom scenes of sumptuous plumbing fixtures, and bedroom scenes of soft luxury. Gloria Swanson, his star, was clothed in the richest of

materials, until she began to take them off. But
DeMille never showed married people involved in
anything unsavory, saving the possibility of
censorship by detailing honeymoon scenes and life
thereafter. While he spent money lavishly on
production, he employed actors who worked for
bottom dollar.

But the stars were not doing badly either; and
personalities from all domains became instant
movie stars. Some of the stars were making so
much money that they could afford to start their
own company. United Artists was formed in 1919 by
Mary Pickford, Douglas Fairbanks, Charlie Chaplin,
D. W. Griffith, Babe Ruth, Will Rogers, and Jack
Dempsey, and it became a powerhouse. Most of the
other stars, however, worked for Metro-Goldwyn-
Mayar, Greta Garbo and Spencer Tracy, for example.
The great directors worked for Adolph Zukor's
Paramount Studios -- Josef von Sternberg and De
Mille, for example. Paramount had the more
unusual performers such as Mae West, W. C. Fields,
and the Marx Brothers. In fact, the difference in
style between the two studios can be seen by com-
paring early Marx Brothers' films done for Para-
mount, full of sexual innuendo, with their later
work for MGM, which had musical production numbers
to blunt the rough edges of their low comedy.
Warner Brothers, meanwhile, was the studio of
gangster films, and musicals; Twentieth Century-
Fox of history and adventure; and Universal of
horror films. A line-up of their employees
reveals each studio's strength and direction:

MGM	Paramount	Warner Brothers
Garbo	Lubitsch	Wellman
Harlow	von Sternberg	LeRoy
Crawford	deMille	Berkeley

MGM con't	Paramount con't	Warner Brothers con't
Garland	Wilder	Cagney
Gable	West	Robinson
Rooney	Fields	Bogart

Twentieth Century-Fox	RKO	Universal
Ford	Astaire	Abbott
Power	Grant	Costello
Fonda	Hawks	Ma and Pa Kettle
Grable		
Temple		
Ameche		

Gradually, actual artistic control of films became the responsibility of the director, as he became able to develop scripts before shooting, and cut the footage after shooting, rather than simply put the pieces together and thereby, leave the controlling work to lesser hands who inevitably made films on formula. Of these directors with total control several stand out.

Josef von Sternberg was born in Germany and was then lured to Hollywood by the opportunity for artistic freedom, as were many other foreign born directors made sound movies that dealt with men and women powerfully drawn together by sexual attraction, usually starring the biomorphic Marlene Dietrich, who promised a hint of sadism with her sexuality. Highly symbolic in his use of sets and through references in dialogue, von Sternberg emphasized deep meaning through sharply contrasting light and dark tones to heighten the moral and sexual tensions in such films as Blue Angel for the German company Irfa (1918) and then in America for Paramount, and also The Devil is A Woman (1935) which features black and white contrast shots of Marlene Dietrich in a series of flashbacks.

Ernst Lubitsch also dealt with sex, but in a more whimsical sense making it passionless to

avoid the roving eye of the censor. Primarily cynical in tone, his plots show the weaknesses of men and women when confronted with basic desires. His handling of this theme in his silent films differed from that in his sound films. In the silents, his camera would hold an inanimate object as a focal point of passion, while in the talkies he worked a light sound track against serious visual presentations. Jeanette MacDonald would repeat "Stop that" with the camera on her clear face, the audience knowing that some sexual game was being played out of its sight.

Most widely respected directors in Hollywood by declining not to deal with sex but rather with the active people in pursuit of self-knowledge and fulfillment. Humphrey Bogart vs. Lauren Bacall in The Big Sleep (1946) is a film detailing the love relationships between two such people. Fighting and quarreling, for Howard Hawks, replaces sex as a sign of love, caring and itimacy.

Similar to Hawks in his concern for the psychology of characterization, John Ford casts his men and women into dramas derived from formulas of medieval morality plays, involving the victory of goodness over the evil of deceitfulness and viciousness. His two greatest films, Stagecoach (1939) and The Grapes of Wrath (1940), sited in the West, to do without the false moral encumbrances of "civilization," show travelers of distinctly different sorts encountering and overcoming evils, exhibiting compassion and understanding as weapons against privilege and violence. Scenes of Tom Joad, played by Henry Fonda, talking to his mother about making the West livable for the Joad family typify Ford's approach.

Frank Capra used humor to show how good old Americans can overcome mountainous problems through their truthfulness and uncompromising principles, and who fight against villains that

are will to use wealth as their chief weapon.
Featuring James Stewart, Gary Cooper, Jean Arthur,
and Barbara Stanwyck, Capra's films, wildly
optimistic in tone, are seen today as interludes
of social comedy. Mr. Deeds Goes to Town (1936),
Mr. Smith Goes to Washington (1939), are but two
of the type. Smith, with Gary Cooper as a "hick"
Senator who believes he can make the "system" work
seems ridiculously naive to audiences of the
post-Watergate era.

One of the most enigmatic of all director's
careers is that of Orson Welles. Famous for his
first film, Citizen Kane (1941), arguably the
greatest film of all time, Welles' later work
shares little in its quality. Based on the life
of William Randolph Hearst, Citizen Kane shows how
wealth and money can never overcome innate feeling
of unhappiness.

While feature films flourished between World
War I and World War II, another aspect of the
motion pictures reached high levels -- the
documentary. Pare Lorentz's The Plow That Broke
the Plains (1936) and The River (1937) make use of
exceptional photography, learned analysis, and
human insight to captivate viewers. Robert
Flaherty's Nanook of the North (1922), one of the
earliest of the great documentaries, was a model
for Lorenzt's work. Lorenzt's work influenced the
United States Film Service and later the United
States Information Agency to produce for com-
mercial audiences footage concerning the war and
later, other pertinent events. The most
remarkable of these films was Louis de Rockmont's
March of Time series and Frank Capra's, Why We
Fight series.

After World War II, which was a boom to
Hollywood box offices, the movies lost increasing
patronage to television. The effect of TV on the
industry was to constrict it in every aspect. The

102

number of movies made plummeted yearly into the
70's. Further havoc was wrecked on the industry
during the McCarthy era as investigations into
alleged communists in the film community cast
suspicion and fear across the country. In an
effort to lure back audiences, the industry came
up with a number of technical gimmicks which
usually served to swell the box office receipts
only temporarily -- Cinerama, 3-D, and Smell-O-
Vision were three of them.

Even though the technicolor process dates from
the beginning of the era of sound films, it wasn't
until the 1950's that color films took over -- the
greatest technical advance since sound. Techni-
color film gave a decided entertainment advantage
over TV, which then was limited to black and
white. Then, when television went to color, film
had to be in color to take advantage of lucrative
TV rights. So, during and after the 50's, movies
lost vast audiences to TV. Then they linked
themselves to their competition to develop another
method of merchandising their product.

Concurrently, most of the original big names
of the industry faded away into the sunset, and
their replacements were not able to break signi-
ficantly new cinematic ground. While provoking
and beautifully made, their films were largely de-
rivative of those that had gone before. Among
this group can be counted Elia Kazan, On the
Waterfront, 1954, East of Eden, 1955, John Huston,
The African Queen, 1951, George Stevens, Shane,
1953, Fred Zinnemann, High Noon, 1952, and
From Here to Eternity, 1953. Additionally, many
films and companies went back to doing hit plays
and popular novels, whose adaptation to the screen
fell short of their success in their original
media. Of comedy directors, only Billy Wilder,
The Apartment, 1960, Some Like It Hot., 1959,
stood out. In fact, American cinema came under
the stylistic domination of foreign films during a
period of the late 50's and the 60's. America's

103

films during a period of the late 50's and the 60's. America's films were "commercial" venture to the foreigners' "artistic" creations. The Japanese director Akira Kurosawa, and the British director Robert Reed, Ingmar Bergman of Sweden, and Michaelangelo Antonioni were the mentors of the new surrealistic style which broke many of the conventions of the theater-dominated American industry and gave American films new vitality. The foreign domination of style and the foreign influence did not have to be, however, because many of the studios had refused to produce films of this type as early as the 1950's on the grounds that they would not bring a high rate of return on the money invested in them. Nevertheless, "underground" film as it came to be known, anticipated many of the developments which foreign film makers used to commercial advantage. Rejecting the traditional plots in favor of lyric invention and poetic structuring, Stan Brakhage, Jonas and Adolfas Mekas, and others, had a small band of followers.

By the early 60's Hollywood had seen the errors of its ways. Recognizing that the battle for mass audiences had been lost to television, but that people were willing to pay to see what television either would or could not show because of its commercial sponsorship and the Federal Communications Commission, movies no longer aimed at many-faceted audience. A new audience was defined -- a group under 30, relatively affluent, white, and educated. Some films were directed at identifiable minority audiences such as blacks, gays, rock music enthusiasts, and so on. The Hollywood code crumbled under the intensification of cinematic style called for by the address of the industry to more limited audiences, and was replaced by a more flexible system. These films, taken as a whole, did away with every social convention of sexviolence, plot and characterization.

The best of the 60's and 70's films also included a sociological statement -- a message.

Of these films, the most prominent were those of
Stanley Kubrick, Dr. Strangelove (1964) -- the
world is not safe from a nuclear disaster because
humans can be crazy; 2001: A Space Odyssey (1969)
-- man may ultimately deem himself by his own
technology in the computer age of his evolution;
A Clockwork Orange (1971) -- the future may hold
in store man's inhumanity to man; Arthur Penn,
Bonnie and Clyde (1967) -- "bad" guys are human
and sometimes better people than the "good guys";
Peter Fonda and Dennis Hopper's Easy Rider (1961)
-- drugs can enhance life's experiences. Bob
Rafelson, Five Easy Pieces (1970) -- a self-
-absorbed person can be unloving; Billy Friedkin,
The Exorcist (1974), the devil is a terrible foe.
Francis Ford Coppola's The Godfather (1972) and
Godfather II (1974), -- the Mafia has morals;
Peter Bogdanovich's The Last Picture Show (1971)
-- small town life destroys the souls of its
inhabitants; Martin Scorcese The Deer Hunter
(1979) -- the Vietnam War was a personal disaster
for its participants.

A sign of maturity of an art form is when it
uses its own history and tradition to successfully
structure a new work. Star Wars (1978) by George
Lukas uses the old tales of Buck Rogers, the
Western and other genres, and puts them in a fu-
ture time of ray guns and interplanetary battle-
ships. The combination produced the biggest box
office film ever, bigger even than the paradigm of
cinematic romance, Gone With the Wind. Of course,
other films had previously used film's own tradi-
tion and history successfully such as Welles'
Citizen Kane, in which the Gothic tradition,
particularly in the opening and closing scenes,
and the use of the detective story motif, actually
hold the film together. That Lucas, as had
Welles, held vast audiences spellbound by using
film tradition integrally in his movies is a mark
that both creator and audience understand the
values of the medium itself.

There are so many films being made each year that it is difficult to see a clear line of the development of the motion pictures. The influences of projected audiences, budgets, directors and stars make a straignt line of development impossible because of their very diversity. However, study of the motion picture as a whole reveals that there are traditional kinds of films, or film genres, which can be more coherently studied one by one, than can the entire corpus of American film. The specific film genres which show the greatest development in America during the twentieth century are the gangster film, the horror film, the comedy film, and the western film.

In America, the gangster film begins with Underworld, directed by Josef von Sternberg in 1927. Gangster films feature characters who are thieves, and occasionally murderers, and their accomplices and girlfriends, who are likely to be prostitutes, all of whom are tracked down and executed by minions of the law. In terms of technique, these films emphasize quick cuts, montages, dissolves, scary lighting and jolting sound crescendoes of gunfire and screams.

The "hero" of the gangster film is the head ganster, usually modeled after Al Capone, who is moody, fearsomely sexual, brutal, and marked by death. Usually he has a soft side meant to endear him to the audience as a man who is not all bad. In the end he is killed, after the audience's morals have been twisted enough by his good qualities so that they identify with him.

America during the Depression of the 30's and afterward to a lesser degree, sought such heroes. The gangster was a natural hero, a fighter of the system which itself was economically crushing its audience at the time.

Darryl Zanuck of Warner Brothers hired news-
papermen such as Ben Hecht to write these films in
a style of realism and explosiveness. The result
for Warner's was a series of box office successes.
Warner's was quickly joined by other studios that
saw lucrative possibilities in the genre. The
Public Enemy (1931) with Jimmy Cagney, Dead End
with Humphrey Bogart (1937), Little Caesar (1930)
with Edward G. Robinson were the best of the type,
as was Scarface (1932 staring Paul Muni as Al
Capone himself, directed by Howard Hawks, written
by Ben Hecht, and produced by Howard Hughes for
Warner Brothers. Its violence was so affectively
portrayed that the Hays Office was pressured to
restrain the production of such films thereafter.
The studios knew a good thing when they had it,
however, and responded by making the hero a
character other than the killer -- an FBI agent
instead, perhaps. G-Men (1935) is one such film
and typical of the derivative type.

Gradually the quanity production of gangster
movies declined through the 1940's; but their
quality reached a zenith in 1949 with White Heat
starring Jimmy Cagney. In general, however, the
big stars, Robinson, George Raft, Cagney, and then
Bogart drifted away from gangster films to those
with more demanding roles, trying to avoid being
typecast.

But then in 1967, and again in 1972, the gan-
gster film was reborn with Bonnie and Clyde and
The Godfather.

In Bonnie and Clyde a measure of joviality is
added to the violence through the use of a blue-
grass musical score which makes the gangsters
mock-heroic figures. Some viewers insisted that
Bonnie and Clyde were being presented as role
models for the rebellious youth culture of the
late 60's, a charge similar to that of thirty
years before about the gangster heroes of that era.

107

Others were affected by the slow motion sequence when the pair is machine-gunned to death at the end of the picture in close-up shots which give a dance of death aspect to their being killed by the law officers. The controversy over the violence of the police and the sentimentality of the presentation of the gangsters only resulted in more people going to see it, as if the presence of Faye Dunaway as Bonnie and Warren Beatty as Clyde was not enough to insure box-office success. Arthur Penn's direction, meanwhile lends a touch of satire not only to the small-town mentality of mid-western America, but to the gangsters, and to gangster films themselves. The gangsters are portrayed as misfits of the Depression to be sure, without hope for the future, but at the same time are woefully inept as gangsters, lovers, and friends. As a result, the audience sees them as the moral characters in the plot and identifies with them, rather than with the law.

Based on Mario Puzo's best-seller of the same title, and directed by Francis Ford Coppola, under the influence of several Italian social societies, The Godfather was an even bigger hit and better gangster film than Bonnie and Clyde. Its sequel Godfather II (1974) was bigger and better than either The Godfather or Bonnie and Clyde.

In The Godfather, Coppola presents the story of a mafia Don, Vito Corleone, portrayed by Marlon Brando, as an aging man watching over a dynasty built on traditional Sicilian values. He attempts to protect his personal family from the abuses of the WASP (White, Anglo-Saxon, Protestant) society. It shows how his values are passed on to the youngest son, the most educated, most WASPish of the entire family.

Corleone's values are not those of the common hood. He will not deal in dope, and he is shot by

members of a rival mob over the issue, he is forced to kill only in an effort to maintain his own "turf". When the mantle passes from father to son, the business of a series of murders to protect the family is carried out in justaposition with a baptism scene. The technique makes the point of the inconsistencies of the patriarchal values as well as the solemnity of both actions, murder and baptism.

Godfather II deals basically with the reign of the younger son, again played by Al Pacino, as he grows up in his role as a don, even tougher than his father. The sequel, while having the virtues of its predessor, also boasts better photography, particularly in the scenes of the Sicilian countryside when Pacino goes to hide out after committing a revenge murder.

Studios in Berlin, Germany, were major exporters of horror films from 1919 with Robert Wiene's The Cabinet of Dr. Caligari. German Romanticism, which is dependent on folk material and legends involving ghosts, goblins, and rebirth, and was a principal influence on Washington Irving's romantic stories such as The Legend of Sleepy Hollow and Rip Van Winkle, and was the source material for many of these films. Imported to America, these films spawned American-made imitations. In general, these films did not reach their height of popularity until the 1930's. It was at that time that directors put into these films some of the same qualities that made gangster films so popular, in that they made the hero a sympathetic figure. Lon Chaney played the type to perfection in The Hunchback of Notre Dame in 1923, and its sequel, The Phantom of the Opera in 1925. But the studios did not take advantage of the inherent popularity of the horror film for five more years.

Finally recognizing a gold mine, Universal Studios tried to cast Lon Chaney in Dracula in

1930. Chaney died before production and Bela
Lugosi was chosen to replace him. Dracula was the
hit it was predicted to become and has been made
over many times, although the original, directed
by Todd Browning, who directed Chaney in other
films, is still considered by many to have been
the best version.

Browninggwent on to direct other horror films,
such as Freaks (1932), about circus freaks, and
The March of the Vampire, (1935) one of the most
memorable of all horror films.

Frankenstein, which was a title role Lugosi
declined to play, is, however, probably the best
and most famous American horror film. Boris
Karloff, as the monster created by Dr. Franken-
stein, goes beyond his creator's control and
escapes, finds a person, a young girl, who will
play with him (making his a sympathetic character
for the audience) but unfortunately drowns her,
and dies in flames. His death reached an apotheo-
sis in sequels such as The Bride of Frankenstein
(1935), The Son of Frankenstein (1939), and later,
Young Frankenstein (1975), a spoof of the ori-
ginal, directed by Mel Brooks, with Gene Wilder as
a madcap Dr. Frankenstein.

Lately, serious horror films have made an
impression on audiences by using stories from
literature, such as those of Edgar Allan Poe,
whereas the previous decades of the 40's and 50's
saw little work in the genre. The House of Usher
(1960) by Roger Corman merges realism, and
necrophilia to create horrific effects.

Alfred Hitchcock is, however, the acknowledged
master of the genre, even though he prefered to
think of himself as a maker of suspense films
rather than horror films. Psycho (1960), starring
Anthony Perkins, features a scene wherein Janet
Leigh is murdered while taking shower, her blood
running into a whirlpool at the mouth of the

110

drain. Other of Hitchcock's films, such as The Birds, have the same sense of mysterious horror which makes Psycho so successful.

Rosemary's Baby, (1968), The Exorcist, (1974) The Omen, (1976), Carrie (1977), Exorcist II (1977) all drew large audiences who were thrilled by the horror of otherwise normal folk becoming agents of the devil or were otherwise motivated to malicious mischieviousness.

American comedy took a while to take hold of audiences compared to other film genres such as melodrama. But by 1913, Mack Sennett and his Keystone Kops were drawing chuckles from their audiences. Charlie Chaplin, Buster Keaton, and Harold Lloyd all followed, but none, of course, was as successful as Chaplin.

Crude, but daffy, Chaplin's tramp character, like Lloyd's wholesome, but erring young man, was used over and over again in generally similar plots that relied on sight gags for their humor.

Chaplin's most typical film is probably The Tramp, made in 1915, which features a number of sight gags which make the little creature a sympathetic character to audiences. Chaplin directed himself in this masterpiece comedy. Chaplin as the main character suffers the world's disdain for the little man in this film in which nuances of gesture on his part carry the communication of emotion from actor to audience.

Harold Lloyd's best picture Safety Last, (1923) contains the cinematic icon of Lloyd's cling to a clock some twenty stories over the street in a mistaken attempt to impress his girlfriend.

Keaton's best, The General, (1926) in the first half is the story of an engineer attempting to get

111

his locomotive (The General) back from the Union soldier who have hijacked it. The second half is essentially one long chase scene of Keaton and his girlfriend pursued by Union troops.

The comedy made by these three was doomed with the explosive growth of talkies which succeeded the silent films in which they starred, and by the rise of another generation of comedians who relied on verbal jokes as well as sight gags to make their audiences laugh. Among these comedians were W. C. Fields, the Three Stooges, and the Marx Brothers, the latter two really a part of the madcap tradition begun by Sennett's Keystone Kops, and then carried on by Mae West, who burlesqued sex and sentimentality.

Of the films produced by this group, My Little Chicakadee, (1940) staring West and Fields lives forever, the title itself having become a cliche' for coming sexual victories. It was so good it placed tremendous pressure on the Hays Office to block distribution of such a piece of pornography.

During the 1930's Fields and his type were pushed aside by the popularity of romantic comedies which relied on the element of sentimental escapism to captivate audiences. Movies of this type, starring Clark Gable, most notably, brought swooning women to theaters in droves and advanced the star system to its greatest heights. Cary Grant, Roz Russell, and, later, Marilyn Monroe all worked this vein of American comedy; and most profitably so in Billy Wilder's Some Like It Hot in 1960. These movies feature slapstick, coy sex, impersonations, mistaken identity, one-line jokes, and elaborate, extended zaniness.

Such light-hearted, essentially meaningless, comedy was supplanted in the 1960's by the American movie producer's version of social comment.

Foolishness was replaced by irony and cynicism, as directors and stars believed that they had a voice with which to make a significant social "statement." Stanley Kubrick's, Dr. Strangelove, (1964), satirizes the nuclear arms race by presenting a psychotic general who believes that communists are poisoning our water, causing deficiencies to "our precious bodily fluids." The failsafe device to save the world from errant nuclear catastrophies in fact fails, as one plane gets through Soviet defenses to drop a nuclear bomb.

Mike Nichols' The Graduate, (1967), the best of these social comedies, satirizes the conventions of the affluent American middle class. Witty dialogue, a great score by rock singers, Simon and Garfunkle, and sharp characterization of Mrs. Robinson, Anne Bancroft, who seduces the young graduate, Benjamin, played by Dustin Hoffman, before he falls in love with her daughter, Elaine, contribute to this work of satiric art.

Woody Allen's work has consistently moved from the madcap towards serious social commentary, becoming increasingly urbane and intellectual, to the point where Manhattan, 1978, really is a serious drama with only occasional humor. His earlier work is based largely on absurd fantasies, such as Bananas, (1971), Play It Again, Sam, (1972), and Sleeper, (1973). These gave way to the more serious Annie Hall, (1977) in which Allen, somewhat autobiographically deals with his love for Annie Hall, played by Diane Keaton, and his own various neuroses.

Western films, as a group, all share the following characteristic: evil characters are pursued and defeated by good characters in an environment where there is otherwise little or no formal law, but plenty of wide open space. The American West of the 19th century is really the hero of these films in its grandure, beauty and wild spirit.

The first Western film was Edwin S. Porter's
The Great Train Robbery, 1903. A series of brief,
but immensely popular films followed in short
order, featuring a plot involving crime and its
legal or quasi-legal revenge. These early
Westerns set the stylistic mode of the type,
featuring fast action, short scenes, obvious
symbolism, shallow character development, and an
emphasis on the vastness of the settings. These
films are like short morality plays that are set
in the Great Plains and similarly underdeveloped
environs. The popularity of this type of scenario
was first established, however, by dime novels
rather than by Western movies themselves.

The strong effects of such popularity can be,
perhaps, more completely understood with reference
to the character of the Swede in Stephen Crane's
short story, "The Blue Hotel." In this famous
piece, the Swede comes to the West filled with
expectations from stories he has read that
violence and frontier justice are realities; and,
through the effect of his imagination on his
behavior, he insures a violent death for himself.

Story writers and film makers since Crane have
had no difficulty in finding heroes and villains,
real, legendary, or purely fictive. The names of
their creations live in the core of our national
history: Wyatt Earp, Billy the Kid, and Annie
Oakley to name a few.

Cecil B. De Mille's The Squaw Man, (1914), was
the first full-length Western to be produced in
Hollywood. It was a box office success inspiring
scores of other producers to make their own
Westerns. Many merely adapted the existing dime
novels to films, taking advantage of the
audiences' identification with the hero's rugged
individualism in a primitive world.

The actors who played these roles, themselves
became national figures, as did the characters they

114

played. Bronco Billy, W. S. Hart, Tom Mix, John Wayne captured the successive imaginations of generations of America. A second level of stars provided entertainment between pictures starring these giants: Ken Maynard, and Hoot Gibson, for example.

While a few silent Westerns show a touch of art through a deft handling of symbolism, the early talkies did little to advance the art, studios considering them mere B pictures. In the late 30's and early 40's, however, the Western became a serious motion picture. The Plainsmen, (1936) starring Barbara Stanwyck put De Mille at the front of those pushing the limits of the Western. John Ford's Stagecoach, (1939) represents the best of these serious Westerns. It is a film made by a director who specialized in Westerns, and who explored the values of pride, humility, courage and cowardice under the big sky of the Western Arizona desert in this film.

Nine characters on a stagecoach are defined as the coach rolls through episodes of dramatic intensity. The drama, itself, is based on the interplay of the staple elements of the Western: the calvary, the bad Indians, the outlaws, the lawmen, the gamblers, and the quiet representatives of the Eastern business world.

Similarly, other great Westerns of the 40's explore the individual in a threatening world. William Wellman's The Ox-bow Incident, (1942) is perhaps the best of these, although today it seems plodding and slow moving. But in its time it seemed rife with moral implication and symbolism.

Two 40's kinds of Westerns which continued the developments of Stagecoach were High Noon, (1952) starring Gary Cooper, who faces the outlaws alone in a small town when the townspeople choose not to

115

get involved, and Shane, (1953), the story of a stranger who helps homesteaders do battle with the predatory cattle barons, and who then rides off into the sunset. Shane is notable because director Fred Zinnemann tells his story through the eyes of the worshipful young boy whom Shane befriends. It is a technique which lends poignancy to the drama of violence.

The 1960's and 70's produced a host of thoughtful Westerns, a style in which a problem is set up that the hero has to try to resolve. Giant, (1956) prefigured the type, with its conflict between oil development and the agrarian Western society. The Misfits, (1960) dealing with the last cowboys, Hud, The Wild Bunch and later, Little Big Man, (1971) are in this mold. Of these, Little Big Man stands out because of its strength of irony and humor brought to bear on the serious issue of the extermination of the American Indian. It debunks the American myths of the West: the "good" cavalry is shown slaughtering a sleeping encampment of Indians; Custer is presented as a psycho, and the Indian himself, the noble savage in death or life, is here a loser among Indian and Anglo.

Other great Westerns during the 60's and 70's revival also injected humor into the genre, thereby turning the serious drama of the early Western into a mock-heroic satire -- Butch Cassidy and the Sundance Kid, Blazing Saddles, (1974) being two of the most popular. On the other hand, Clint Eastwood's portrayal of a violent no-nonsense hero in series bunch of Italian made, so-called "Spaghetti Westerns" is a direct throwback to the early type, featuring simplicity and action. There seems to be no end to the American taste for films about a past that never was.

In all then, the motion picture art is one peculiar to the twentieth century. It is a complex art involving, among other things, the economics of studio production, the vision of the director, and the performing ability of the director, and the performing ability of the actors and actresses.

In summation, cinematic techniques developed fairly early in the history of the movies with the work of Griffith, Melies and von Sternberg. The developments of different kinds of movies led to highly developed film types, such as gangster movies, horror movies, and Westerns. The break-down of conventions which marked the other arts, also occurred in the movies. During the early 60's and later, cinematic conventions of all kinds fell as directors aimed their work at clearly defined audiences. Even with that, however, movies continued to rely on their own traditions to produce box office successes, such as Star Wars.

The mixture of realism and expressionism which found its way into the other arts of the late 60's is not so prominent in the movies. The movies, however, continue to rely on traditional formats, perhaps because each movie attempts to satisfy separate kinds of audiences among the broad mass of moviegoers. Perhaps it could be said that while all movies are not for every one, all movies are for someone.

117

Recommended Reading

Amberg, George, ed. The New York Times Film
 Reviews: A One Volume Selection 1913-1970.
 New York: Quadrangle Books, 1971.

Anderson, John, and Renee Fulop-Miller. Ameri-
 can Theater and the Motion Picture in
 America. New York: Johnson Repring
 Corporation, 1938.

Arnheim, Rudolf. Film as Art. Berkeley:
 University of California Press, 1957.

Batfoc, Gregory. The New American Cinema: A
 Critical Anthology. New York: Dutton, 1967.

Bohn, Thomas. Light and Shadows: A History of
 Motion Pictures. Sherman Oaks: Alfred
 Publishing Co., Inc., 1978.

Casty, Alan. Development of the Film: An
 Interpretive History. New York: Harcourt,
 Brace, and Jovanovich, Inc., 1973.

Clarens, Carlos. An Illustrated History of the
 Horror Films. New York: Putnam, 1968.

Denley, David. Awake in the Dark: An Anthology of
 American Film Criticism, 1915-Present. New
 York: Random, 1977.

Durgant, Raymond. The Crazy Mirror: Hollywood
 Comedy and the American Image. New York:
 Horizon Press, 1970.

Early, Stephen C. An Introduction to American
 Movies. New York: New American Library,
 1978.

Eidsvik, Charles V. Cineliteracy: Film Among the
 Arts. New York: Horizon Press, 1978.

Everson, William K. American Silent Film. New
 York: Oxford University Press, 1978.

Gottesman, Ronald, and Harry Geduld. Guidebook to
 Film. New York: Irvington Publishers, 1972.

Griffith, Richard. The Movies: The Sixty Year
 Story of the World of Hollywood and Its Effect
 on American From Prenichelodeon Days to the
 Present. New York: Simon and Shuster, 1957.

Higham, Charles. Art of American Film 1900-77.
 Garden City: Doubleday and Col, Inc., 1974.

Jacobs, Lewis. The Rise of the American Film: A
 Critical History. New York: Teachers College
 Press, 1968.

Kael, Pauline. I Lost It at the Movies. Boston:
 Little Brown, 1965.

Lindgren, Ernes. The Art of the Film. New York:
 Macmillan, 1963.

McClure, Arthur F. The Movies: An American Idiom.
 Cranbury: Fairleigh Dickinson University
 Press, 1972.

Mekas, Jonas. Movie Journal: The Rise of the New
 American Cinema 1959-1971. New York: Mac-
 millan, 1972.

Murray, Edward. Nine American Film Critics: A
 Study of Theory and Practice. New York:
 Unger, 1975.

Rhode, Eric. A History of the Cinema from Its
 Origins to 1970. New York: Hill and Wang, Inc.,
 1976.

Rotha, Paul. Film Till Now London Vision. New
 York: Mayflower Press, 1960.

Sklar, Robert. Movie Made America: A Cultural
 History of American Movies. New York: Random,
 1976.

Spottiswoode, Raymond. Grammar of the Film: An
 Analysis Film Technique. Berkley: University
 of California Press, 1950.

Weiss, Paul. Cinematics. Carbondale: Illinois
 University 1975.

Wood, Michael. America in the Movies. New York:
 Dell Publishing Co., 1976.

CHAPTER V

ARCHITECTURE

It could be correctly said that the era of the the post-Civil War Industrial Revolution marked the beginning of modern architecture in America. The reason is that the period developed a wealthy class who had the needs and means for buildings in a new style which required professional designs. The design process moved from the control of the artisans and constructors to that of the professional architect.

The result was that from the period of 1860 or so to around 1890 vast changes occurred in the design of buildings in the U.S. Before this period the populace was quite satisfied with Greek and Roman styles. Their buildings demanded little technological development because their uses were essentially those of the classic period. Furthermore, Americans themselves had no sense of an "American" style of architecture.

During this period the telegraph was invented, as was the telephone, the elevator, and the light bulb. All of these inventions and other technical breakthroughs, which we take for granted today, demanded buildings of a different sort to take advantage of the speed, efficiency and economics which these inventions offered. Telephones allowed stores and office buildings to expand, elevators allowed buildings to grow taller, and artificial lighting allowed construction techniques to provide workspace independent of natural lighting. Additionally, improved modes of transportation allowed workers to commute to work from beyond mere walking distance, allowing workplaces and service buildings to spread out from a central core area of development. Improvements in heating and sanitation systems allowed for more workers to use a given building and increase the possibilities of its usefulness.

In general, however, these opportunities during the Victorian era, which allowed for different styles, were not grasped by the architects at that time. With few exceptions, they were held back by cultural concerns peculiar to the Victorian era, which emphasized tradition and decoration. In effect, the engineering advances were not supported by aesthetic advances which could be offered by the architects. In general, this was a period of conservatism; and architecture was a part of that mood.

The Great Fire in Chicago of October 8, 1871, offered an opportunity for architects of the period to create new buildings in a metropolis which was the urban center for an essentially agrarian surrounding countryside. Economic factors, however, became a greater influence on the architectural aesthetics, than was the influence of the site. Henry Hobson Richardson, Louis Sullivan, and Stanford White all saw these factors and responded with advances in design which took advantage of the existing new deconomical contruction techniques.

Richardson, who had already established a strong reputation on the East Coast, designed a series of buildings in Chicago that, although still a part of the eclectic Victorian style, show a steady march to simplification and the abandonment of ornamentation, the results of which are clearest in the Marshall Field Building.

Richardson was a profound influence on Louis Sullivan. The similarity between Sullivan's Auditorium building and the Field store by Richardson is a direct result of Sullivan's studying and adopting Richardson's ideas that the facade of the building should identify and not obscure the internal organization of the building -- or in Sullivan's words, that "form follows function," the principle made famous by Frank Lloyd Wright some years later.

The Auditorium building, one of the earlier multi-storied structures in Chicago, represents the development of architecture at a crossroads. It uses load-bearing exterior walls in the older style; but its foundation and interior framing is of cast and wrought iron, a forerunner of future buildings which have steel skeltons.

White, of the architectural firm of McKim, Mead and White, which emphasized classical construction in their projects, developed aspects of the American colonial style on problematic sites. The W. G. Low House, Bristol, Rhode Island, 1887, used the traditional New England shingle style but in a highly defined Swiss chalet motif. The large porch, the vast amount of glass, and enormous pitched roof make it unique and timeless.

These adaptive but still traditionally European styles gradually gave way as new materials and ideas produced by the industrial age led to changes of enormous proportions. New structures, such as railway stations and department stores became buildings on which to experiment with metal frames and glass. New developments in the steel--making process made the use of large load bearing capacity steel beams to support these buildings possible. Because there was no tradition of such buildings to draw on, new avenues were available for revolutionary changes in design. These experiments in design began with smaller structures, such as houses and small factories, but gradually came to be used on larger buildings where the function of the building, without regard to traditional styles, determined the form of the structure.

Taking the lead in this area were the British who designed structures emphasizing simple geometrical shapes, particularly the rectangle. In America, Frank Lloyd Wright and Louis Sullivan attempted to construct buildings based on such

austere structural designs. However, the use of
the Beaux Arts tradition of eclectic design all
but shut off growth in architecture during the
period of the late 1800's. The result was that
such buildings as those at the Chicago World's
Fair designed by the Burnham and Root Corporation
and McKim, Mead and White, were done largely in
classical styles. Two of the greatest examples,
however, of large buildings of the time empha-
sizing geometrical structure are the Monadnock
Building and the Reliance Building.

When the Chicago fire of 1871 leveled much of
the city's undistinquished buildings, the perfect
opportunity was presented to architects, besides
the renowned Richardson, Sullivan and White, to
develop the use of steel framing to build taller
and taller buildings, thereby relieving the city
of congestion and making better use of commercial
land. A prototype of the kind, featuring in-
creased use of glass with the greater height af-
forded by structural steel, was the Home Insurance
Building designed by William LeBaron Jenney and
constructed between 1883-1885. At ten stories,
not more than some buildings in New York, it had
an internal metal skeleton carrying the weight of
the external shell, the principle upon which later
skyscrapers were to be built. In 1887-89 Holabird
and Roche developed the Tacoma Building whose
metal skeleton carried a minimal brick and terra-
cotta skin which expressed its engineered design.
Burnham and Root's Reliance Building of 1894 takes
these implications further by eliminating walls
and substituting glass, with supporting elements
kept to an engineering minimum. This building
marks the beginning of the understanding of the
skyscraper as a glass enclosed metal grid.

Louis Sullivan and his Danish partner Dankmar
Adler, and a draftsman named Frank Lloyd Wright
saw at once the importance of skyscrapers and

built them in places other than Chicago. Sulli-
van's skyscrapers like the Wainwright Building in
St. Louis (1890) find him emphasizing the height
of the building by designing for the piasters
separating the windows to flow virtually unimpeded
to the top of the building. He succeeded in
marking the layering effect of the succession of
floors in the building by incorporating ornamental
bands under the windows and throughout the attic,
and by topping the building with a cornice which
emphasized the linear quality. Sullivan developed
the vertical quality further in his Guaranty Trust
Building in Buffalo (1874-95) making the piasters
even narrower and putting them together with the
graceful arches of oval windows at the top. Under
the influence of art nouveau, he presented consider-
able decoration at this top level of the building.
The ornamentation is said to emphasize the decora-
tive quality of the terra-cotta, rather to make it
seem a weight-bearing material.

In his last great commercial building , the
Schlesinger and Meyer Department Store, Sullivan
limited the decorations to a fringe running the
length of the building at the second story. He
gave emphasis to the horizontal rather than the
vertical by using Chicago style windows, consist-
ing of a large pane of fixed glass flanked by
smaller movable glass panels on either side. Thus
the building emphasizes neither verticality nor
horizontality. The first two floors consist of a
bronze and plate glass screen with a melange of
ornamentation which hides the ventilation hard-
ware.

As fast as the understanding of the skyscraper
grew however, the faster it was crushed into
traditional architectural formats. An example is
the Woolworth Building of New York (1913) designed
by Cass Gilbert. It is fifty-two stories but
finished in late Gothic stone sheathing.

While American architects were making impor-
tant advances in design, in Europe during the
first part of the century, until 1930, there
evolved a complex of movements the result of
which, taken together, can be called the
International Style. This style made wide use of
ferro-concrete or glass or metal sheathing
attached to a steel skeleton. These buildings,
encompassing all sizes and shapes, were both
experimental and economically practical. Many of
the architects of these buildings, forced from
their homelands under the pressure of Nazism,
migrated to the United States. Of these Walter
Gropius, who arrived in 1937 as Professor of
Architecture at Harvard University, Mies van der
Rohe, and Marcel Breuer who joined him, are most
noteworthy in spreading ideas of the Bauhaus School
of Design, which propagated the International Style.
The major concern of this European school was for
the designing of the integration of the arts and
other areas of activity into an American architec
tural style.

At the time of their arrival, the architec-
tural style of America followed the Beaux Arts,
eclectic style, with the exception of those
efforts noted previously. Each of these immigrant
architects attacked the problem of establishing
the new style in a different way.

Gropius believed in the process of collabora-
tion among all concerned with the building of a
structure, so that the building would have artis-
tic merit and social usefulness. He founded the
Architects Collaborative in 1945 to design build-
ings world-wide. The result was the creation
of the American Embassy in Athens, a structure for
Bagdad University, and an apartment for the Berlin
Intervase Exhibition. The most ambitious was the

127

design for the Bost Back Bay Center in 1953, which was never completed, composed of a "T" shaped complex on piers above walks and driveways. The buildings included a convention center, a shopping arcade, a hotel, and a massive parking area. It was a total environment of buildings with richly textured facades.

Mies van der Rohe, working on a similarly large scale, brought to completion the new campus of the Illinois Institute of Technology based on an abstract design and sited in a poor area of Chicago, an educational urban renewal project composed of buildings erected on modular principles. In 1951, he tested his ideas about skyscrapers through the completion of apartment buildings on Lake Shore Drive in Chicago, and, in collaboration with Philip C. Johnson, with the Seagram Building in New York in 1956-57. These are a direct development of the ideas of Louis Sullivan. His modular system of construction was also a further refinement of Sullivan's ideas. He used a suspended frame structure which resulted in a completely open interior space in such buildings as the hall for the Department of Architecture and Design for the Illinois Institute of Technology (1956) and the National Gallery Berlin 1962-68.

Unfortunately, the Bauhaus influence combined with the economics of simplification, many times brought into existence building which were cold, austere, inhumane and multiplicative in their design and mechanistic. Many large buildings designed during the 1930's, and later, show how false such a rigid aesthetic can be. Nevertheless, the major component of that style, the right angle, the geometric basis of the design, went relatively unchallenged. An exception, however, were two buildings at the New York World's Fair of 1939, which showed early that there were, in fact, other simple, yet expressive designs. The General Motors Building by Norman Bel Geddes, and the Ford Motor Exhibit Building, by Walter Darwin Teague,

used curvilinear designs which streamlined the buildings and gave them a sense of dynamism. These designs, which were an attack on pure functionalism, offered an organic relation of the building to its sight through seemingly native principles of design. Yet they retain a cubist inspired sense of formalism with a rational and clearly mechanistic basis.

Similarly, there are many contributions by others following the Bauhaus principles of Gropius. Marcel Breuer's career is notable for achievement in several distinct areas of architecture. Breuer's own second house in New Canaan, Connecticut, of concrete and field stone tempered by the use of weathered wooden beams, demonstrates his ability to make the structure integral with the side and local materials. Breuer has also been successful with a lecture hall at New York University, using rough poured concrete almost exclusively, in cantilevered fashion, in combination with seemingly random size and placed windows. On the other hand, his St. John's Abbey, in collaboration with Hamilton Smith, shows a lighter touch, with honeycombed concrete walls and resolutely tapered pillars contrasting with the massive, detached bell tower composed of great slabs of concrete set on piers.

The Columbian Exposition of 1893, featuring buildings done in a distinctly Neo-classical style, probably set back architecture by native Americans. That style proved so popular possibly because expansive Americans liked to think to themselves as imperial rather than merely imperialists -- America as the new Rome or Athens. But to Sullivan and others the style was a hoax, a cruel hoax. In Sullivan's case the lingering attachment of America to the Neo-classic style, led to his decreasing popularity, and in Wright's case to early obscurity.

As a result, the period from 1900 to the mid 1930's has been called by amny a wasteland of

architectural development; but, in fact, it can be seen as a period of amalgamation. The period of the turn of the century had actually produced some significant new designs. During this period these prototypes slowly but surely inched this newer design away from a few select urban areas. While the Neo-classic style, represented by the Columbian Exposition still held sway, the technological advances were better and better understood by the artisans all across the country.

Furthermore, the rapid development of California during these years shows that conservatism did not dominate everywhere. The pioneering liberalism of the people who settled this area allowed architects such as Charles and Henry Greene to design houses with Oriental stylistic touches, which bear similarity to Wright's prairie house designs. A Spanish colonial revival in the San Diego area, led by Burtram Goodhue, fitted together regional traditions and their adaptation to the site, ideals represented by Wright and others. Wright, himself, built houses in California, during this time, of concrete and wood which reflect the same regional traditions reflected in the work of Goodhue.

These buildings were influenced directly by the force of those who commissioned and who designed them. They demanded functionally efficient architecture, which meant simplicity of design -- the most space for the money -- resulting in little or no ornamentation or decorative features. The economic force became, in time, a principle of design of simplicity for its own sake. Appearance and purpose, function and form were necessary adjuncts largely because of economic pressures, particularly during the 1930's after the stock market crash of 1929.

Meanwhile, the great American architect, Frank Lloyd Wright developed a distinctive style. In 1893, Wright left Adler and Sullivan to work on his own. His only large scale commissions for

many years were the Larkin Building in Buffalo in 1904, Midway Gardens, Chicago 1914, and the Imperial Hotel, Tokyo 1915-22. Thus, much of his energy went into smaller structures such as houses. Borrowing from the shingle style of Richardson, these early houses featured open or screened verandas enclosing two sides. The cruciform plan, with the central area of hearth and utility core, was also an important design feature.

The Ward Willitts House, Highland Park, Illinois 1900-02, inspired by the Japanese exhibition hall of the 1903 Chicago exposition, had the cruciform plan, low-gabled roof, accented plain facade and the central fireplace and utility units. The interior flows to the exterior through its horizontal thrust, in a style which Wright adhered to in succeeding efforts. He called it his prairie house style. The horizontal quality suggestive of the plains is repeated within the structure by low ceilings, and unorthodox angles. The greatest example of this style is the Robie House, Chicago, 1909. This house centers on the hearth, on one long axis. Its horizontal roof line is accented by cantilivered steel beams anchored at the center reaching to the outdorrs, with chimney and gables at right angles to the walls.

In 1936, Wright completed his most famous house, the Kaufman House, Falling Water, at Bear Run, Pennsylvania, sited integrally at a water fall by means of a centilevered terrace of ferro-concrete. It contains most of the marks of the Wright style, a centralized utility core and hearth which anchors the cantilevered area and is placed at right angles to it, low ceilings giving a cave like interior, which still suggests open-ness and efficiency, an interior which flows to the exterior, and the use of native materials, and local stone in this case. Following completion of

some of his earlier prairie houses, Wright had turned to California and built houses there, showing Japanese influences, out of concrete and glass. Both the Japanese stylization and the concrete are prominent in the design of Falling Water. Taliesin West, begun 1936, Wright's own home near Phoenix, Arizona, features many of these same ideas set within his typical rectangularly shaped buildings.

Wright, however, did not limit himself to the rectangular as his basic geometric configuration. The Johnson Administration Building features curved walls of brick with no window. The windows are replaced by a translucent band encircling the building in six layers of glass pieces. Skylights admit some direct natural lighting. The building is supported by a number of terraced reed-like interior columns with wide capitals.

Other circular buildings designed by Wright include the Jacobs House of Madison, Wisconsin, 1948, the David Wright House in Phoenix and most importantly the Solomon R. Guggenheim Museum of New York, finished in 1959 after Wright had died. It was the only big commission Wright ever received in New York, and an inordinate amount of bureaucratic delay to obtain city approval for its unusual design held up its completion.

It consists of an exhibition hall and an administration building. An interior spiral ramp winding up the outside wall of the building marks the gallery space where works are exhibited, with each ramp suspended on pylons wider than the one below. An enormous skylight at the center of the circle is augmented by strip lighting on the ramp. Patrons take an elevator to the top and casually walk downhill to view the exhibitions in a series of bays which allow serenity of contemplation, but intercourse with the large areas of the museum by visual contact when turning away from the exhibits themselves.

Among Wright's disciples were Richard Neutra and Rudolph Schindler, who built houses following Wright's ideas and the International Style. Neutra's Lovell house in California, built into a mountainside by means of a series of terraces, helped create the proto-type California hillside house.

Mies van der Rohe was not without his disciples either, chief among them being Philip Johnson, whose own house in New Canaan, Connecticut, follows Mies' theories of merging interior and exterior space Johnson's house is really a glass box set in the woods.

Of greatest influence on Mies followers has, however, been the Seagram Building which he built with Johnson. A symbol of the power of the Seagram empire, it is a tall rectangular slab completely symmetrical on a wide symmetrically landscaped plaza. Its steel skeleton is clear in contrast to its window frames, and it is, according to Mies, built on "the organic principle of order as a means of achieving the successful relationship of the parts of each other and to the whole". In turn, it has led to the creation of a host of spectacular, but similar buildings, among them, Lever house by Skidmore, Owings and Merrill, the twin towers of the World Trade Center by Minosura Yamasaki, Eero Sqarinen's CBS Building, and I. M. Pei's John Hancock building in Boston.

Working on many different kinds of buildings rather than only on office buildings, Louis I. Kahn has been of great influence. His Richards Medical Research Building for the University of Pennsylvania, (1957), composed of a series of interconnected closed squares for the labs, has an effect of simplicity and airiness that has been widely imitated, most notably by Paul Randolph in his Married Student Housing at Yale 1961. Rudolph's work is not entirely derivative, however, in that his highly individualistic Mental

133

Health Building uses massive areas of rectangles
nakedly, if not brutally, presented to the viewer.

Cultural centers have seen much architectural
action, particularly those designed within the
last twenty years. The John F. Kennedy Center for
the Performing Arts in Washington by Edward Durell
Stone is similar to his design of the American
Embassy in India. Ralph Rapson's Tyrone Guthrie
Theatre, Minneapolis, 1960-61; Lincoln Center by
Philip Johnson; Bunshaft, Skidmore, Owings and
Merrill's Hirshhorn Museum and Sculpture Garden,
and Breuer's Whitney Museum in New York are all
attempts at putting art in an artistic environ-
ment. Such a goal is similar to that offered by
Eero Saarinen for travelers at Dulles Airport and
at his TWA Terminal at Kennedy Airport.

Because of the shortage of energy, and the
resultant skyrocketing energy costs, the inter-
national style of architecture has met detractors
in theelate 70's. The anonymity of the glass and
steel, the repetitiveness of the sterile facades,
the coldness of the buildings in design, and dis-
satisfaction with their high fuel consumption have
fostered critics who see the style as a failure
and who offer a modern alternative.

The old style modernist believed that the
structure of a building should be expressed and
should be clearly presented, and that the shape of
the building should reflect the activities of its
occupants. Buildings, in short, were engineeered
machines to Wright, van der Rohe, Gropius, and all
the Bauhausists. They were machines which were to
be efficient, economical, standardized, and open.
These architects, from their elitist viewpoint,
also believed that architects could change
people's behavior by changing their surroundings.
They believed that man's progress was in their
hands.

The beginning of the end for modernism came
when the Pruitt-Igoe apartments in St. Louis were

dynamited by the U. S. Government in the 70's.
They had been subsidized high-rise apartments for
the poor; every family with its own niche in the
hive-like building. Before it was destroyed,
people took to vandalizing the buildings and each
other, trying, according to sociologists, to
assert lost identity and rebel against the
frustration that the conformity of their environ-
ment forced on them. The idea that architects
could create social change was finished when the
last cinder block hit the earth.

Co-ordinately the architects' scorn of
suburban housing developments was similarly
revealed to be wrongly elitist. People demanded,
and bought, and moved into detached houses in the
suburbs while architects and others decried the
similarity of tract houses, somehow preferring
that they live in apartments and townhouses, which
are obviously more similar than the houses of any
tract. In the suburbs, the people added personal
touches to their houses, such as entrance lights,
landscaping arrangements, additional rooms, and
asserted the individuality and sense of territory
that American have always traditionally thought of
as a mark of the national character, architects
not withstanding. Perversely, the architects
responded to this rejection of their views by
building steel and glass towers downtown for these
people to work in during the day.

When archtects thought about detached housing
the 60's, they thought of, in a self-aggrandizing
way, of an engineered method of construction which
would allow the owners of the homes to take the
homes with them when they moved. Astonishingly,
they were not thinking of upgraded mobile homes,
but modular units which could be trucked to a new
site. Little did they realize what the people
already knew. It is easier to buy another house,
and end up with a better mortgage payment as a
bonus, than it is to move the whole house to
another site.

135

The biggest fraud of modernism was revealed in the late 70's, however, with the advent of the energy crisis. That fraud was the ideal of functionalism -- the idea that form follows function. To the modernist, functionalism means simplicity of line and transparency; the ideal was one of visual simplicity. In building, this extended to the idea that a wall should not arbitarily separate the inner from the outer, that the two should merge, that the building should be unobstrusive visually on its site. This is the idea behind the all-glass home of the greatest modernist architect, Philip Johnson, in Connecticut. The concept is similar to the concept of minimalism which flourished simultaneously in painting.

Clearly, functionalism, then, was a stylistic concept, not a technical one. That this is so has enormous implications in an energy-short world. Were modernism functional technically, rather than stylistically, we would not have billions of dollars of giant glass buildings in our downtown areas demanding billions of dollars of fuel for them to be heated and cooled. When one considers that a thermopane window has ten times less insulative value than an average wall, the technically non-functional, but stylistically "functional" building, becomes a monumental architectural error. The Sears building in Chicago, Chicago's tallest, made of steel and glass, uses as much energy in a year as the entire town of Riverside, California. The twin towers of the World Trade Center uses enough energy to power a city of 150,000 people. Thes buildings are stylistically nice, but are a functional disaster.

The startling quality of the visual imprint of modernistic artitecture was part of its style. As such, modernism in architecture, which celebrates the individual conception of the architect in its design, is of a piece with the aesthetics of the

136

abstract expressionists in painting, the acid
rockers in music, the surrealists in drama. And,
just as those who celebrated individuality in
their art were replaced by those offering a new
realism incorporating technical advances within a
traditional vision, so has the same begun to
happen in architecture.

True functionalism, not merely stylistic
simplicity, is offered by those incorporating the
architecture of solar engineering in their de-
signs. The radicalness of the shift to consi-
dering energy in the design function will be slow;
but a realistic appraisal by architects of the
needs of people will force it to reality. The
radicalness of the change can be pictured by
imagining a high rise office building with its
north face covered with masonry block made of heat
retaining thermocrete, with judicious use of glass
on the other sides. The visual disjunction that
this would cause in our cities illustrates the
magnitude of the challenge awaiting architects in
the 80's.

Solar architecture is not new to this country,
however. In fact it has a long tradition dating
from the siting and construction of pueblos by the
Indians of the Southwest, to row houses built in
Chicago in the 30's by George and Fred Keck.
South facing windows, with overhangs calculated to
allow passage of the winter but not the summer
sun, and heavy drapes, were not viewed as too
unusual by those viewing these houses. Later,
through the 40's and 50's, solar architects were
mostly concerned with solar shading and reducing
heat gain in the glass boxes built by the moder-
nists; but at the same time work was done on
winter heat gain by architects and engineers with
an eye to the efficiency of energy use.

In the 70's the energy crisis begun by the
Arab oil embargo of 1973, then heightened by
subsequent disruptions of supply and leap-frogging

137

costs for all forms of energy, brought heating techniques under serious study. Of late, the term solar architecture has thus come to apply in description of buildings which are designed to integrate the thermal, directional, and seasonal aspects of the sun to provide both the building's heating and, in some cases, its cooling and thereby save on energy costs. With the rise of interest of integral design by architects, the use of solar hardware has declined in favor of passive solar structures. Typically, passive solar design is thought of in conjuction with smaller buildings such as homes, stores, and small office units. Advances in engineering may yield giant solar high rise buildings, however.

Existing passive solar buildings are of three types. One is the direct gain design, in which heat captured from the sun through south facing windows is stored in the floors or walls of the building, which consists of massive heat absorbing materials. A second design consists of putting a heat absorbing wall, called a Trombe' wall, between south facing glass and the living area. As in the first design, the thermal mass of the wall gains heat during the day, gradually releasing it at night. Additionally, however, heat is convected over the wall or through registers at the top of the wall during the day into the house for added heat. A third design is one that consists of attaching a greenhouse structure to the south wall of the building. Registers convect heat into the house during the day and somewhat into the evening.

These systems can also be used in conjunction with heat storage systems of hot air, or water, produced by collectors, or from the passive design itself. A well-made solar building can get 70% of its heat on a seasonal basis from the sun.

In an effort to gain even more efficiency, some of these structures have been sunk into the ground to take advantage of conditioning qualities that earth structures offer. In this design, developed by David Wright among others, only the south face of the building is open to the elements. Its glass face absorbs the necessary solar energy in a building which defeats air infiltration and is well insulated. While there is a growing number of domestic buildings of this "cave man" design, there are also two successful large buildings which have been constructed. One of these is a student center and bookstores at the University of Minnesota; the other is an elementary school, called Terraset, located in Reston, Virginia, and partially built by money granted by the oil-rich country of Saudi Arabia.

An example of domestic solar architecture is David Wright's own house at Sea Ranch, California. It is partially sunk into the ground as a protection from wind. And its sun-facing side is almost all glass. When temperatures rise too high, small vents at the top of the windows are opened, causing convection and the expulsion of the hot air which naturally rises to the ceiling. Opening skylights also serves the same purpose. The combination can lower the temperature from 85F to 70F in a half-hour. Additional cooling can be gained by drawing the drapes on the sun-collecting windows. Cool air can be drawn into the house by opening vents at the bottom of the windows. A solar curtain, consisting of three layers of aluminized polyester sandwiched between a pleasingly designed cotton material, keeps warmth in the house. The back wall of the house is concrete, the floor brick on sand. Both absorb solar heat during the day and allow it to slowly release at night into the house. Some of the glazing acts as flat-plate, thermosyhon solar collectors, giving the occupants hot water. The sod roof on the house and the living level sunk

into the ground moderate temperature swings inside
the house, the dirt maintaining a temperature with
less variation than the space inside the house.
The house is so energy efficient that one winter
the wood-burning stove used for auxiliary heat was
only used on two evenings. The temperature,
generally, in the house maintained a range between
70°-80° to 65° without its occupant using any form
of energy for heating or cooling other than the
sun.

Solar is clearly the new reality of modern
architecture. One building, however, opened in
1978, may be considered a solar building manque'.
That is the East Building of the National Gallery
of Art, designed by I. M. Pei, in Washington, D.
C.

Having taken ten years to construct, the East
Building is finished in the same Tennessee marble
as the classical main Gallery building, but it is
shaped roughly like the trapezoidal lot upon which
it is sited. Thus, while it is similar to the
main building in texture, it differs radically in
shape.

Its interior is composed of two connected
triangles, a division of the trapezoidal shape.
The triangles are connected by a hugh skylighted
court covered by 16,000 feet of glass in tetra-
hedron shape. A good percentage of the building
heat for the galleries which are housed in the
lounge of the buildings two trianglar upper levels
around the courtyard might be generated by solar
energy during the day, the bulk of the time the
gallery is open. However, one of the triangles
blocks the direct solar gain offered by the
skylight. So the heat gain is not as great as
could be. A sunscreen of bright aluminium rods
provides some shading and softening of the
direct light from the sun, which provides some
of the building's interior illumination. The
marble walks and concrete floors are of sufficient
mass to store much of the solar energy as heat,
releasing it slowly at night and on cloudy days,
but the light that hits it is only indirect
sunlight, so not much is captured.

Of course, the building was not designed as a
solar building, and its quality is found in its
other characteristics. The galleries themselves
hug the long legs of the the outside wall of the
building of the larger of the two triangles.
Diamond shaped corners are cut out of the tiers
surrounding the courtyard to make small intimate
rooms housing separate kinds of exhibits. At the
three corners of the triangle connecting these
galleries are "bridge galleries," having the
larger exhibits.

The smaller of the two triangles contains the
museum's offices and the Center for the Advanced
Study in the Visual Arts. It rises eight stories,
surrounding a six story reading room.

On the outside, the facades are of marble
facing, cunningly designed to look as if it were
more substantial than mere facing, and augmented
by exposed re-inforced concrete. Inside, the
marble has been sculpted with great craftsmanship
along the wall of an escalator to indicate verti-
cally on the walls. The concrete is used for the
horizontal elements, such as the floor and bridges
connecting the galleries. Like the marble, it is
finished smooth, and in fact, contains marble
chips to give it more grace.

The outstanding visual impact of the building
derives from the acute angles of the corners of
the triangular shapes, angles which are repeated
in shapes and designs inside the building. In
fact, the acute angles have drawn so much atten-
tion that only one year after the building had
been open, grimy finger marks had discolored the
marble on one corner of the building as visitors
touched the corner as if the acute angle of the
corner itself were art.

The times have brought a new realism to
architecture. Architects now appraise building
design in relation to climate and site, and in
relation to the realities of energy resource
conservation when faced with the high cost of

141

heating and cooling with non-renewable forms of
energy. In addition to its energy saving feature
solar is a design which restores a sense of
independence and adventure to American building,
qualities Americans traditionally think of as
characteristics of themselves.

Recommended Reading

Andrews, Wayne. *Architecture, Ambition* and Americans: *A Social History of American Architecture.* New York: Free Press, 1978.

Allsop, Bruce. *Modern Theory of Architecture.* Boston: Routledge and Kegan, 1978.

Brolin, Brent. *The Failure of Modern Architecture.* New York: Van Nostrand Reonhold, 1979.

Burckard, John, and Albert Buck Brown. *The Architecture of America: A Social and Cultural History.* Boston: Little Brown and Co., 1961.

Fitch, James. *American Building: The Environmental Forces That Shape It.* New York: Schocken Books, Inc., 1975.

Hammett, Ralph. *Architecture in the United States: A Survey of Architecture Styles Since 1776.* New York: John Wiley and Sons, 1976.

Jordy, William. *American Buildings and Their Architects, Vol. 3 & 4.* Garden City: Doubleday and Co., Inc., 1972. 1972.

Mumford, Lewis. *Roots of Contemporary Architecture.* New York: Dover, 1972.

Wodenhouse, Lawrence. *American Architects From the First World War to the Present.* Detroit: Gale Research Col, 1977.

Wright, Frank Lloyd. _The Natural House._ New
York: Horizon Press, 1954.

Wright, Frank Lloyd. _Frank Lloyd Wright on
Architure: Selected Writings 1894-1940._ ed.
Frederick Gutheim. New York: Duell, Sloan
and Perci, 1941.

CHAPTER VI

SCULPTURE AND PAINTING

The twentieth century has been an age of
sculpture, witnessing the development of new ideas,
forms, and materials in the presentation of three
dimensional images. It rises from a period stretch-
ing from the late seventeenth century until the
early twentieth century when little development
took place in the art form. In the United States,
until the twentieth century, only August St.
Gaudens stands out during that time period.

The man who was most responsible for the modern
development of sculpture was the French Auguste
Rodin, who rejected the sentimental attractions of
his peers and looked to Michaelangelo and Donatello
for a clear handling of nature and scupulous atten-
tion to true representation. He emphasized move-
ment and power through the use of mass and light.
He worked from clay models to be able to alter the
musculature for precision until the true gesture
could be made, then transformed the clay into
plaster, marble and bronze, relying on the medium
to create nuances of meaning, particularly through
the variation of light on the mass of material.
Most notable for its ability to express the
artist's view of his subject is his Balzac, (1897),
which proceded through various detailed stages
until at its conclusion this was a statue stripped
of idiosyncrasy and presented as a symbol of the
writer. The statue is, in short, the beginning of
abstract sculpture.

In a roughly similar fashion, such sculptors as
Aristide Maillol, Antoine Bourdelle and Charles
Despieu sought to make their sculpture more re-
alistic by preserving the natural effects, and the
suggestiveness of their subject matter, through
depicting their subjects in active poses.

Honore Daumier was an amazing sculptor, but
one whose work was largely unknown at the beginning
of the modern period, and thus was not an in-
fluence. He made many sculptures in a style

146

prophetic of that of the twentieth century, and
when finally "discovered" they revealed corners of
techniques that reinforced the notions of in-
creasingly abstract sculptors, emphasizing formal
consideration over emotional content.

All of these sculptors, and later artists such
as Renoir and Degas, however, stayed within the
essentially vertical spiral style of the Renais-
sance. Rodin's The Burghers of Calais (1886) and
The Gates of Hell (1880-1917) are two of only the
few which emphasized new and different directions
in the use of space and mass, mainly the extension
of the work along a broader horizontal beam.

Cubist sculpture, which developed around 1910,
was directly inspired by Cubist painting and by
Constantin Brancusi, whose attention to planes,
curves and the finish of his material produced a
stir at the Armory Show in 1913. Later interest by
sculptors in African art, which offers lines in
geometrical reduction of natural forms, also in-
fluenced the growth of twentieth century American
sculpture to seek forms which dealt severely with
the issues of space and form, with lesser attention
to historical meaning. Of course, Cubist sculp-
tures by such Europeans as Jacques Lipshitz and Henri
Laurent were of great inspiration as well.

Because of the work of Europeans, it is not
surprising that during the first forty years of the
twentieth century, the greatest sculptors of the
country were European immigrants -- Gaston Lachaise
(1882-1935) and Elie Nadelman (1882-1946). La-
chaise's work is derivative of Maillol's, differing
in its suggestion of power and sex. Nadelman, on
the other hand, trained in Paris, as was Lachaise,
sought to abstract essential lines in his work, and
succeded in producing amusing yet powerful works
which feature planes intersecting through a series
of smooth curves in figurative subjects. Native
Americans were also active, however; Max Weber,

primarily a painter, produced a number of astonishing Cubist sculptures during that period as did John Storrs. Neither was influential to other sculptors on an important scale, however.

Meanwhile Saul Baizerman (1889-1957), developed a technique of hammering copper sheets into expressive forms in a manner of high relief sculpture. The front then is a negative of the back of the sheet. The result is more two dimensional then three dimension. In fact, the general drift of sculpture in the United States was more in the direction of carving rather than casting, and on a small scale rather than the large scale of Rodin and the other Europeans. Most of these pieces also are heavily indebted to European abstract expressionist painters in their construction.

Not comparable to any other artist in the field during this period is Isamu Noguchi, born in Los Angeles in 1904, brought up in Japan, trained by Brancusi in Paris, and a resident of the United States since 1929. He combined the influences of Brancusi, Giacometti and the Cubists, as well as Japanese principles of order in design, to emphasize repetition of shapes in series. While he has designed furniture, assemblages and various kinds of constructions, his best work has been in stone and steel on a massive scale. These works tend to consist of the repetition of a structure offset by a complementary mass.

Within the last thirty years there has been an increased attention to constructions utilizing found objects of all kinds, keeping them at stasis or putting them into motion or producing effects with lighting on them. The most outstanding works by American constructionists have been done by David Smith, (1906-1965) who initially was influenced by Picasso's welded steel structures done during the 1920's and by Gabo's realistic manifesto, which was that the open spaces of the

148

sculpture are its forms as definitely as the lines
of the construction itself. Smith's works were
done in a period in which he used geometric forms
in a series of combination. During most of his
career, however, Smith worked on a series of
sculptures in styles which seem to bear little
resemblance to each other. His Agricola con-
structions done during the 50's, are an example, as
are his later Sentinel and Cubi series. In gene-
ral, his style tended to show him using more and
more found objects incorporated in the construc-
tions.

Reuben Nakian, born in 1897, like Smith, mostly
a constructionist, works mainly in terra cotta and
plaster in an expressionist style, but his pieces
have a less obvious formed order than Smith's work.
Unlike Smith, Nakian developed a unique approach to
solving problems of materials by using plaster
spread over cloth attached to metal armatures. An
example is Rape of Lucrece, (1953-1958) which took
five years to complete because of the delicacy of
the medium.

Working in a more traditional medium, Theodore
Roszak's works are geometric constructions featur-
ing color, surface texture, and linear planes,
suggesting power uncontrolled and without direction
ofuse.

More elegant in style, are the works of Seymour
Lipton, born in 1903, and Jose de Rivera, born in
1904, whose masses of metal tend to be thin and
delicately twisted into undulating lines and
blocks. Less elegant is the work of Mark di
Suevero, born in 1933, which employs the found
object on a grand scale -- structured steel "I"
beams combined with other large objects in pre-
carious balance.

On a miniature scale, artists in the last few
decades have been producing works by assembling
already formed objects into suggestive orders, a
practice which owes very much of its conception to

149

the old Dada idea of the found object as art. This medium knows no bounds, and its possibilities defy categorization. A few examples demonstrate the range that American artist have given it.

Joseph Cornell (1903-1972) put things together neatly and in orderly, linear fashion to suggest aspects of his everyday life. As a whole, this assemblage of his function as a visual biography of a mundane existence.

Louise Nevelson, born in 1900, fills wooden walls with boxes full of arranged found objects, painted in a uniform color to separate the objects from their visual associations. Almost her opposite, in that her work takes materials and forces them into shapes suggestive of life, is Louise Bourgeois. She uses round balls of marble or other material to stand away from a rough cut base.

Richard Stankiewicz is probably the most important junk sculptor. He uses bits of old machines arranged in an abstract pattern and gives the work an ironic title. As it rusts, the title becomes all the more ironic as in The Secretary. Lacking the use of this tone of irony, which is similar to that of Kurt Schwitters, the German abstractionist who worked earlier in the century, are a number of other current sculptors of found objects, among them Lee Bontecou, John Chamberlain, and Mary Bauermeister.

On the other hand, sculptors have been making life-like figures which, while not presented ironically, nevertheless are charged with social comment on the loneliness and tastelessness of American life. George Segal's The Diner (1964-66) and Duane Hanson's Tourists (1970) are primary examples.

Some sculptors use humor as an outright formal concern. Claes Oldenburg, born 1929, relies on an unusual scale to create his humor with sculptures

of giant clothespins, baseball mitts and balls, and the like. Alexander Calder (1989-1979) made dainty, but sometimes huge, mobiles that depend on their airy lightness and good humor to create their personal charge of creativity.

Working on a smaller scale artists like Robert Rauschenberg and Jasper Johns create small-scale sculptures which contain a suppressed level of social comment in good humor. Rauschenberg's Monogram, (1959) is essentially a painting with a goat standing inside a rubber tire. Johns' Painted Bronze (beer cans) 1960, the mold and its cast of two beer cans, therefore in different sizes, is also representative of the type.

Working on a grander scale than has been imagined by most audiences, in fact generally beyond their view, are the earthworks artists: Dennis Oppenheim (Canceled Crop -- a field with a giant "X" plowed into it) 1969; Robert Smithson (Spiral Jetty, 1979 -- an enormous spiral getty built from the dry shore line into the Great Salt Lake; and Christo (Running Fence -- a curtain running for miles along the coast of California) are the most outstanding examples. They make simple forms that are adapted or, not adapted to, the environment.

The emphasis on simple forms led to such works in the 60's as Robert Morris' placement of blocks of wood or pieces of metal laid on the gallery floor and Sol Le Witt's placement of lumber in strict geometrical patterns in a galley room in his pieces Sculpture Series A.

While these are static sculptures, other artists, influenced by Calder's success with mobiles, have created sculptures utilizing light and motion to constantly rearrange the formal elements for new contemplations. George Rickey's Four Lines Up (1967), which moves gently in the wind in random fashion, is but one example among many using motion as a source of form.

151

Similarly, Preston McClanahan's Star Tree
(1966-67), consisting of plexiglass rods and
fluorescent light, features a changing con-
stellation of light reflected and projected by
three towers which only faintly resemble trees and
is an example of changing light and translucence as
a source of form.

Among all American sculptors, however, two
stand out for their breadth of influence, per-
sonalistic styles, and devotion to creating new
forms through forceful experimentation. Their work
combines the devotion to forms common to the
abstract expressionist style, which dominates twen-
tieth century art, and a depth of human spirit and
humor which simultaneously praises and criticizes
its own environment. Their work has made a deep
impression not only in the world of art, but in the
world of the American culture as a whole. These
two sculptors are Alexander Calder and Claes
Oldenburg.

Following the rise of the expressionistic im-
pulse which followed the Armory Show of 1913, and
continuing through a period when others had a
retrenchment of vision during the Thirties and
turned to traditional figurative sculpture, a
conservative mode, heavily bound by tradition,
Calder built pieces emphasizing the "made" or
constructivist style, rather than the representa-
tionalist. Humor and fantasy in Calder's work
gives a soft edge to his abstract shapes and
usually sterile raw materials of plastic and metal.
The very fact that Calder all but ignored stone in
favor of modern industrial-age materials is sym-
bolic of his vision of and commitment to modernism.
Seeming to omit homage to traditional sculptural
concerns, such as symmetry, balance, and a con-
sistent finish to the materials, Calder made these
all relative matters in his work, substituting
humane randomness for absolutes in construction.
His work has informal symmetry in formal balance,
and a natural surface finish. The repetition of
forms upon which his sculptural identity lies is,

in fact, inexact repetition, seemingly standard-
ized, but yet not so. His formula sets well in a
modern environment suffused with mechanical re-
petition and exact duplication under "controlled"
circumstances in products ranging from buildings to
roasting chickens. His famous invention, the
mobile, a sculpture which moves with the wind, is,
in fact, a machine which is all appearance and no
function, a sardonic joke on modern technology.

Calder began by making animated toys in a
little shop, the most famous of these creations
being a miniature circus made of wire and wood.
The circus, an anachronism in modern society, was
to become for Calder a vehicle of expression of
his humor and intelligent commentary on society.
The circus pieces established Calder's reputation
among senior artists in Paris before 1930.

In Paris, he was influenced in his construc-
tion of shapes in an open field by Joan Miro, a
Spanish abstract expressionist, whose enigmatic
paintings consist of shapes irregular yet smooth.
These same shapes are to be found in the construc-
tions of Calder in the 1930s. Another influence
was the Dutch abstractionist Piet Mondrian. The
shapes and lines of Calder's earliest immovable
sculptures are similar in their severity to those
of Mondrian's paintings. At any rate, Mondrian's
insistence on the abstract led Calder to drop his
representational work by 1932 in favor of non-
representationalism.

It would be a mistake, however, to say that
Calder's work is heavily derivative. While the
playfulness of Miro, and the severity of Mondrian
are present in his work, the adaptation of these
basic inherently unremarkable qualities to his
creations results in peculiarly American forms,
and ones which are, individualistically, Calder's
own. Calder's mobiles are alive, responsive, and
evanescent. In that they constantly vary in

configuration internally and in relation to their
setting as they move through the breeze, they are
eternally made new, temporary yet permanent. They
are rhythmical, energetic, lively, lyrical,
mathematical, geometrical, engineered, symbolic,
non-representational, pragmatic and ironic.

His mobiles are of varying sizes and construc-
tion designs, and do not lend themsleves to
description because they are ever changing. His
last mobile, hanging in the East Building of the
National Gallery of Art, a geometrically shaped
building designed by I. M. Pei featuring acute
angles, open space and natural light, brings fun to
a gallery visit because it hangs moving, in opposi-
tion to the stolidness of the building itself, and
the image of the art pieces in the galleries in
general. Here tons of metal rotate and revolve in
varying patterns at speeds determined by the
building's mechanical heating, air conditioning and
ventilation system, and in response to air currents
pushed by natural solar energy. At one point an
arm swings overhead of visitors on the top floor
level, at a height low enough for some otherwise
staid and composed gallery-goers to jump up off the
floor and touch it. Many cannot resist the whimsy
to involve themselves with this lively sculpture.

During the 60's and 70's Calder put much of his
energy into the creation of immovable sculpture,
calling them stabiles. Done on a giant scale, many
of them are monuments to abstraction, and similar
to the work of David Smith, although they, like the
earlier mobiles, still have the whimsy of a Calder
creation. They still feature the kidney shapes
that Calder adopted from Miro's paintings for his
mobiles, but are larger, solid yet light, and
generally painted black or red-orange. No attempt
is made to hide their engineering. Rivets and
welds are part of the over-all design. Some of
stabiles suggest biomorphic or anthropomorphic
shapes; others, outrageously large geometric

154

patterns, are similar to the Minimalist sculpture of artists far younger than the then aging Calder.

An example of an important Calder stabile is The 100 Yard Dash, completed in 1969. Made of steel plate painted orange, it consists of two freestanding parts and reaches a height of fourteen feet. There is little overt connection to a sprinter in the design of the five separate arms which shoot into the air in mainly triangular form. The riveting of the pieces of steel represents a design which is at once clearly utilitarian in places, but in others it seems to denote track shorts, or spread legs. Close examination of the dynamic relationship of triangle to triangle suggests a stop action camera sequence of a sprinter emerging from the starting blocks in a rolling motion as he develops forward momentum at the beginning of his race. The curly pieces extending from the tops of two of the triangles suggest hair flowing, or the pumping motion of the arms of the sprinter as he gathers power.

On the other hand, this stabile can be viewed without references to track. It can be seen as a rhythmical, monumental series of hard orange surfaces establishing a relationship between ground, air and sky, pulling in force from all three -- a pleasing design suggesting power and contrast.

Claes Oldenburg was born in 1929 in Stockholm, but moved with his family at an early age to the United States, receiving his art training at Yale University and the Chicago Art Institute. Arriving in New York in 1956, after Rauschenberg, Johns, Frankenthaler, and Louis had exhibited there many of the pieces which gave abstract expressionism significance in the art world, he was drawn to tribal and primitive art then popular in the galleries. In the 60's he shifted his attention to the human figure and the creation of art pieces of the urban milieu.

At one point he created Store, a recreation of a city store of 1961, out of plaster and chicken-

155

wire. The figure of a mannequin dominates the objects for sale, its whiteness suggesting the emptiness, the deadliness of consumerism. The following year Oldenburg developed his recreation idea further, making colossal sculptures, a hamburger seven feet in diameter, for example, right in the gallery where it was on exhibit, and entitling it Floor Burger. It was made of canvas covered with latex or liquitex and stuffed with foam rubber and paper cartons. The resultant work is a fantasy, at once humorous and witty, an inherent self-contradiction of the reality and dreams of hungry small boys. The construction with its companion piece, Ice Cream Cone, together suggest male and female sexual imagery. Many of Oldenburg's works feature just such imagery underneath their colossal humor.

Succeeding Oldenburg soft sculptures, representational pieces of parts of the home (such as Bedroom Ensemble in 1963), and sports subjects, (such as Standing Mitt with Ball), join his commercial food subjects in his repertoire of subjects. All maintain a level of sexual suggestiveness. All of these pieces derive from one of his earliest pieces Ray Gun, 1959, a ray gun suggestive of male sex organs, made of newspaper soaked in wheat paste and spread over chicken wire and painted.

One of Oldenburg's most successful works is his 1970 work, Lipstick on Caterpillar Tracks, which was to be placed at Yale University in a courtyard located between a Romanesque building and an international style building -- a place made more serious by the names inscribed on the facades of a classical building listing important military battles. Until removed by an ungrateful Yale administration, there it sat in bright orange and yellow standing on a movable base, with its levity and unpretentiousness in an otherwise solemn spot surrounded by marble. The metal of the farm

implement, the caterpillar, and the cosmetic item, the lipstick, mounted on the tractor reaching straight up, is at once a phallic symbol and a symbol of mindless destruction. His female implement welded to a male implement, also becomes a symbol of man's sex, violence, destruction.

Oldenburg clearly tries to present the paradoxes of contemporary America in a detached manner. In this case, his artistic understanding of the forces of society in disharmony during the period of social upheaval of the Vietnam War was deemed an intruding element. The sculpture was sent on tour by Yale University, the artist's alma mater, as a kind of sculptura non grata.

Finally, greater mention must be made of the phenomenon of earth sculpture as practiced by Robert Smithson.

Among Smithson's works are Asphalt Rundown, Rome, 1969, which is essentially a man re-created landslide, and the famous Spiral Jetty. Both are sculptures on gargantuan scale; not properly sculpture but rather earthworks. While Smithson did smaller pieces for indoor museums, his work on his outdoor projects chronologically precedes the work of the more famous earthworker Christo, and is thus historically more important.

Deriving his ideas from minimalist artists who sought to subject objects to demythification by repeating them serially, Smithson went one step further, taking art out of the gallery and bringing it back to the land. He worked with agricultural, urban and geological forms, finding order in them on a more natural, less artifical scale than which could be presented within the confines of traditional indoor forms. He literally went back to the land, in the same sense as had the Romantic thinkers, such as Emerson and Thoreau, over one hundred years before.

157

Smithson was part of a movement that had ample precedents in Indian art and even the work of Jackson Pollack and action painting. It took off after shows at the Dwan Gallery, which Oldenburg also participated in, and at Cornell University in 1968 and 1969. Here artists brought land forms to the attention of critics. After exhibiting at both places, Smithson then became a consultant to the firm building the Dallas-Fort Worth Regional Airport, proposing for them a <u>Tar Pool and Gravel Pit</u> piece, and thereby developing some respectability for his work.

Smithson gained notoriety shortly thereafter for his Non-Sites. At Cornell, an early piece was made of gravel piles and mirrors. His goal, at this stage, was to conceptualize his art, to break down perceivable systems, to substitute a non-technological approach to order, and revise the thought processes that saw his art. <u>Non-Site, Franklin New Jersey</u> illustrates the inherent complexity lying within the natural context.

First Smithson chose a site. Then he obtained an aerial photograph which detailed the places of various ore sites on the site. Next, he drew converging lines on the map and intersected them with parallel lines, thereby forming fine trapezoids. Finally, he made bins of the same form and size as the trapezoids and filled them with ores in the same proportion as that revealed in the photographs. To Smithson, then, art was action merged with thought, a record of the creation is part of the art form.

In 1970, Smithson created <u>Spiral Jetty</u>, his most important work. It is a 1500 foot coil of rock, salt crystals, earth, and algae that loops into the Great Salt Lake, outside of Salt Lake City, Utah. To Smithson "Instead of putting a work of art on some land, some land is put into the work

of art." Here the making of the spiral jetty is of equal importance to the viewers as is the resultant essentially useless, and therefore, artistic, jetty. The memory of its making is the art, not the object. The audacious scale of the enterprise serves to underscore the point.

Conceptural art in general is a record of an object or a re-presentation of the object and therefore, stems from artists like Smithson, and Oldenburg. The staging of happenings and art "events" grew from this idea, from Les Levine's Cornflakes -- six lithographs of 50 giant size boxes of Kellogg's Cornflakes poured on a field to Andy Warhol's familiar Campbells soup cans, to all manner of kinetic, luminist or filmic forms, balloons to lasers to Polaroid snapshots. All of these conceptual formats are a type of sculpture, however. While conceptual art is not in great re-pute at the close of the 70's, during the 60's and early 70's it created quite a stir among art audiences interested in Pop Art. In the 80's however, interest has lessened in this form, with constructionist sculp-ture once again coming to pre-eminence.

Painting

Twentieth century American art, at first, was a result of the effects of American immigration policies just prior to the turn of the century which produced a great jump in the population. Urban centers in the Northeast swelled with the new inhabitants. The change in these centers became the subject matter for the modern masters of a new American style of art.

A group of artists calling themselves the Charcoal Club met in Philadelphia to share experience, models, and theories which became the beginnings of realistic painting in America. Similar to the authors of realism in literature, these artists had some background in reporting and were, in fact, influenced by the new style of writing which was sweeping through the American literati. Their realization of detail and its truthful presentation earned them many detractors and also earned them the label of the Ashcan School. But the development of their style was perhaps inevitable given to the changes in American society during the period.

Led by Robert Henri, (1865-1929) who had studied in Europe, they portrayed how ordinary people in urban settings go about their lives amidst the drabness, if not corruption, of urban influences. Of course, there was political content to their art. Henri, a socialist, insisted in dealing with the masses, the great lower class, as an artistic and humanistic subject matter. He did not believe that artist should be, intellectually or socially, above his subject. He saw the artist as a worker among workers. Henri also had a macho streak among his prescriptions -- that artists have "guts," that they be fighters.

160

Among the group influenced by Henri was George Luks -- a reporter for the Philadelphia Evening Bulletin who had also studied art in Germany and had been impressed by the work of Franz Halz. Halz' painting emphasizes fun, laughter, and movement among its subjects, men and women in saloons, for example. Luks, however, found himself with little interest in happy scenes and was more concerned with depicting the struggle of the urban poor.

A second member of the group, who portrayed his urban subjects doing their daily chores, was John Sloan. Sloan painted many New York scenes of the commonplace with emphasis on sentimental details. His art was, however, sufficiently controversial in its time to have been too vulgar to exhibit in 1905 by the American Watercolor Society. A follower of Henri's politics, Sloan was a cartoonist for the Socialist journal The Masses.

William Glackens, the third member of the group, tended more toward the middle-class at play in his subject matter. He was influenced more than Sloan and Luks by the developments in Europe of impressionnism. Using that style he showed a taste for working men in their pursuits in parks and restaurants.

The fourth member of the group, Everett Shinn, was the most humorous of the group, dealing with satire, by means of caricatures, of fine paint and line, to project meanings built on distancing the artist from the audience. His work forces an intellectual as well as visual apprehension of his paintings. His paint and pastel application, like that of Glackens, has overtones of French impressionism.

The group first gained notoriety in New York with an exhibition at the Macbeth Gallery in 1908, held in reaction to a series of rejections and bad

treatment by the National Academy of Design. The
four were joined by Arthur B. Davies, Ernest
Lawson and Maurice Prendergast, and together became
known as "The Eight".

Davies' paintings are not similar to those of
Sloan and the others as they are lyrical evocations
of nudes in outdoor settings, for example, and very
romantic in conception. Nevertheless, his work,
like that of the others was not in the main stream
of American taste at the time. His exhibiting with
the Ashcan group was, therefore, not related to a
similarity of his style with theirs, but to a
dissimilarity of his style with the dominant forces
of the time.

Davies' later style is heavily Cubist in execu-
tion/ with blotchy plains of color, and shallow
depth, but without the grand design of total
Cubism.

Ernest Lawson's work is not Ashcan and not
similar to either of Davies' styles. Instead, it
is dependent on American impressionism, dealing
with rivers and countryside.

Of all these painters, perhaps the most
arresting by his use of technique and design was
Maurice Prendergast. Influenced by French symbo-
lism, Prendergast's work joins the abstracted
quality of the French school with depictions of the
middle class at play outdoors.

In 1913, Arthur B. Davies, as President of the
Association of American Painters and Sculptors,
along with others, put together an exhibition in
New York at the Sixty-ninth Regiment Armory called
the International Exhibition of Modern Art, and
thereafter called the Armory Show. Thirteen
hundred works were exhibited for one month, showing
major European and American artists from mid-
nineteenth century through 1913.

In February, the International Exhibition of Modern Art opened in New York City. It was an exhibition without any precedent in American art history and its influence is unequalled.

The idea of the exhibition in the minds of its organizers was to show the American public that American art was a viable national expression, the equal of its European counterparts. Davies, an artist of traditionalist landscape paintings, assisted by other artists, notably Walt Kuhn, attempted to give American artists great commercial opportunities through the publicity to be generated from the showing.

Modeled on the Sonderbund exhibition in Germany, an encyclopedic but ephemeral gathering of major European and American art from the mid-nineteenth century through 1913 was grouped by Kuhn and his helpers into five categories: 1) the classicists, including works by Ingres and Degas, 2) the realists, including works by Courbet and Manet, 3) the romanticists and symbolists, including the enormous total of thirty-eight works by Odilon Redon, 4) the moderns, including the work of van Gogh, Rousseau, Roualt, Seurat, Munch, Maillol and Lehmbruch, Kandinsky, Picasso, and Braque, as well as the sculptures of Brancusi and Matisse.

An American section, the fifth, consisted of the older American painting, the Ashcan School, impressionism, (including works of John Twachtman and J. Alden Weir, Davies and Kuhn and members of Arthur Stieglitz's group, 291), and the synchronists, who believed that the pure colors in nonrepresentational compositions could parallel authentic reactions in the same way as music; they wished the audience to experience the color, forms and composition directly on the senses; included was the work of Morgan Russell and Stanton MacDonald-Wright.

The total result was a scandal. Americans were not prepared for this assault on their traditional

163

understanding of art theory and practice, which until then, was limited to the documentation of the democratic ideals that the nation was founded on, and on the belief that paintings should be of and by the people. Noncomprehensible art drew the outrage of the public and the scorn of President Theodore Roosevelt. Leading art critics like Kenyon Cox thought that a grand joke was being played on Americans interested in art, that the show was a kind of P. T. Barnum Circus display where the suckers were the audience.

The cause celebre' and image which supplanted Davies' pine tree flag, that Massachusetts had used during the Revolutionary War, for a symbol of the revolutionary exhibit, was Marcel Duchamp's Nude Descending a Staircase, (1911). It drew an insincere form of flattery in the form of parody. Newspapers staging mock contests urging viewers to find the nude in Duchamp's painting.

The European works by Degas, Courbet, Manet, Delacroix, Renoir, and Redon and lesser known French symbolists were received with disdain. Newly available works by Brancusi, van Gogh, Rousseau, Roualt, Seurat, Munch, Maillol, Matisse, Kandinsky, Picasso, and Braque fared even less well.

The public felt that the Armory Show was an abomination. They felt cheated out of seeing real art by these weird representations, titled to seem to raise expectations that the paintings were what they were used to seeing, such as Nude Descending a Staircase.

Among the artists, the Armory Show was a failure of a different sort, for it showed European art to be in advance of artistry in America -- pointing out particularly how the Americans were indebted to French symbolism. But it did expose America to art

164

on an unprececedented scale; and it brought American art into the consciousness of America. It also provided a forum for artists to discuss their works and develop a bond among themselves, giving them an identity.

Amidst the clamor which he helped create, Marcel Duchamp came to settle in America. In this country, he created found art objects, breaking down barriers in sculpture just as he had in painting. What Nude Descending a Staircase was to painting, Bicycle Wheel, a bicycle wheel on a stool, was to sculpture, as was La Fontaine, (1919) a urinal with the name of the plumber it was purchased from, R. Mutt, on it. This piece was ignominiously rejected for an unjuried show by the Society of Independent Artists of which Duchamp was vice-president. It came to symbolize a radical approach to art, Dada, which was to influence artists in America thereafter, as an attack on middle-class taste using humor and paradox. "Dada", the removal of all formulas and rules for art, was the name of the movement which emphasized the unusual and the usual as works of art without regard to meaning.

It might be said, then, that there were in the first decades of the twentieth century in America three groups: the traditional artists of the National Academy of Design, the realists of the Ashcan School, and the European-influenced group which gained credence with the Armory Show. These last artists were associated with a gallery at 291 Fifth Avenue in New York. The media of these artists included photography -- 291 was run by Alfred Stieglitz, a leading photographer -- painting, and sculpture. While it was a haven for the avant-garde photographer, 291 had controversial shows involving painting as well, among them an exhibition of drawings by Auguste Rodin, and, later, an

exhibition of the work of Constantin Brancusi, Amadeo Modigliano, Picasso, Cezanne and Henri Rousseau. The general public was not encouraged to like these works; the elite, the intellectuals who "understood" abstraction or other fellow artists were the audience to whom 291 and its associates played.

An example of the role of 291 in the development of American art was its effect on the American movement called synchronism exhibited in the paintings of Stanton MacDonld-Wright and Morgan Russell. These were composed of geometric planes of color in non-representation alignments.

Geometric abstractions were also used in more traditional ways to illustrate emblems and flags, as in the work of Marsden Hartley. These forms also were adapted to landscape painting, as Hartley did in his views on Mount Katahdin, and Joseph Stella did with his quasi-representational works of urban landscapes such as Brooklyn Bridge in his 1922 work The Bridge.

Similarly, John Morris painted images in abstraction of what he saw around him in suggestion of nature. He portrayed indirectly, through a low level of abstraction, cityscapes and landscapes. His use of large brush strokes and constrastive colors seems more active than that of Hartley with whom he shared so much.

More abstract than Morris' is the work of Arthur Dove (1880-1946). His depictions of sounds through the visual medium results in a pleasing synaesthesia in Fog Horns. His interest in collage, an inherently abstract media, derived from ideas of the French Cubists, is less abstract than the French because his materials are relied upon to give direct literal meaning, whereas the French attempt to communicate on a suggestive, more abstract, level.

166

Still another artist associated with 291, and in fact the wife of Stieglitz, is Georgia O' Keeffe (b.1887), whose clear depictions of objects use lines so sharply focused as to give them an unreal quality. The technique abstracts those objects from reality to the degree that they become symbols of the actual object they so startlingly represent, particularily in her depictions of cows, animal parts, and skyscrapers. An example of the former is Cow's Skull, Red, White, and Blue.

There were other artists who received inspiration from the avant-garde efforts of the time. Stuart Davis, who studied with Robert Henri, was one of the first American artists to see symbolic value in name brand packaging. His paintings of a cigarette package, Lucky Strike (1921) is really the application of commerical design to abstract canvas. Later he shifted to icons of America -- barber poles, and other signs, to express his American vision. He continued to explore the limits of content with the use of words or word parts to give interior logic to his canvases, each letter beaming an abstract form of line and color and having total meaning only in contrast with other letters and shapes on the canvas. His best effort in this marriage of the written word to the canvas is Rapt at Rappaports (1952).

An artist who carried Davis' middle phase of employing icons on the canvas in a stark, expressive presentation based on observable scenes was Charles DeMuth (1883-1935). By foreshortening and the use of sharp lines, he brought geometric forms out of grain elevators and other man-made and natural objects. His painting My Egypt celebrates the power of the nations bread basket to generate foodstuffs as the source of strength of the American system. Its style has a strong geometrical presentation. DeMuth, like Davis, also looked

167

to the printed word as a source of icons in his abstract but representational work. I Saw the Figure 5 in Gold is based on a poem by DeMuth's friend, Dr. William Carlos Williams, using the figure 5 and the word Bill as the central facts of the painting.

The use of sharp lines became an entire school of art in the late twenties, a school called the Precisionists. Its members included Charles Sheeler, Niles Spencer and Preston Dickinson. Sheeler, foreshortened his perspectives and used sharp lines to define light and shadow. His depictions of factories and machines are less noteworthy for their ability to depict these objects than for their ability to organize clear geometric shapes in an arrangement featuring its own interior logic.

Edward Hopper was another artist whose work typifies the period. Hopper's cityscapes are similar in many ways in terms of subject matter to John Sloan. In fact, Hopper, like Sloan, studied with Robert Henri; but whereas Sloan emphasized the life of the city, Hopper emphasized the loneliness of the city in some paintings depicting vacant stores in dull tones with sharp lines. He shows the dullness of everyday life in the color, and the potential of the city in abstraction through the sharp edges.

After the Depression, American art was dominated by three separate but related ideas, 1) regionalism, marked by simple and popular subjects, 2) suspicion of European inspired art, 3) social comment on the good and bad aspects of American society. These issues led to two separate groups of painters, the regionalists and the social realists.

The regionalists sought to exalt the virtues of American life in the heartland of the Midwest.

They used nostalgia as a vehicle for developing sentimental reactions from the viewer of this work. Paintings of Kansas scenes in simple detailed style, showing man's hard-fought control of nature, typifies the work of John Steuart Curry, one of the foremost regionalist painters.

Thomas Hart Benton, the most popular of the regionalists, had studied other styles of painting before settling on the regionalist made. He painted, as he said, in a way that could be understood by everyone, that was democratic and meaningful to all Americans. Benton, who lived and painted in New York, traveled all over the United States looking for a typical America, finding it in places like Texas for his painting Boom Town and then in Martha's Vineyard for People of Chilinoh.

While painting people going about their lives in what could be called daily America, Benton purposefully destroyed photographic realism in his painting by employing disjointed perspectives. He used flowing rather than sharp lines to define loose but muscular figures drawn out of scale. His attention to composition and movement was to become a large influence on abstract expressionists, particularly one Jackson Pollock.

Under a series of publically and privately supported financial programs, Benton produced a number of murals employing these techniques on a grand scale. His figures of average citizens dancing and gambling mark the use of folk art materials in the tradition of high art mural painting. Perhaps the greatest example of his eclectic technique is the mural cycle on the social history of Missouri in the state capitol. It features Huck Finn and Jesse James, to the exclusion of Missouri's political figures.

Benton's later paintings, however, are more international in style than his earlier regionalist

paintings. He employed Biblical and mythological
figures as subjects for his paintings and placed
them in backgrounds of American landscapes. In
fact, his paintings from this period are remi-
niscent of the work of the Spanish artist El Greco.
One can conclude from the change of Benton's art
that regionalism, despite his beliefs in its being
truly American, limited Benton's art enough for him
to feel imprisoned by it.

Another American realist of the midwest, Grant
Wood of Iowa, painter of probably the most famous
painting of this type, American Gothic was so
particularly popular in America that American Go-
thic has come to represent the entire regionalist
style. The painting is of a hardworking elderly
American farmer and his wife in front of their
typical midwestern farmhouse with its equally
typical Gothic window. The figures personify the
determination and strength of character of mid-
westerners, as well as the toll that a life of hard
work has taken from them, and what it has left
them. On the other hand, perhaps satirically, the
figures also reveal the narrow-mindedness and
provincialism of a life that knows few joys save
the accomplishment of hard work.

The latter humorous interpretation melds nicely
with the obvious intent of another of Wood's
paintings The Daughters of the American Revolution.
The painting shows a group of old ladies sipping
tea. It was painted in response to the attack of
the DAR on his choice of making a stained glass
memorial to Iowa veterans of World War I at a
Munich factory. In an ironic touch, Wood depicts
the women in front of Washington Crossing the Dela-
ware by Emanuel Leutz of Germany.

Many of Wood's paintings treat the mythology of
American history, such as The Midnight Ride of Paul
Revere, and also Parson Weems' Fable, of Washington

170

chopping down the cherry tree. It features Parson
Weems looking outdoors at the mature face of George
Washington (as rendered in Gilbert Stuart's famous
portrait) atop a little boy's body as his father
presumably asks if George did it.

The socially conscious artist, in contrast to
the regionalist, depicted the difficulties of life
during the period, or the pitiful avenues of escape
from life that a degraded environment afforded.
These works are similar to those of the Ashcan pain-
ters. This later generation of urban realists,
however, showed people involved in tawdry activi-
ties, thereby making political comment on the
causes of the dismal life of the laborers, factory
workers, and city hustlers, transients, and the
indigent. Among these painters, are Reginald
Marsh, whose paintings feature exacting detail, and
the Soyer brothers, whose sympathetically arranged
portraits contrast with Marsh's non-judgmental
style.

The use of painting as political comment was
developed farther by two other artists, Jack Levine
and Ben Shahn. Levine's caricatures of political
figures, featuring their corruption in images of
gluttony is a more generalized approach than that
of Shahn, who dealt with specific instances of his
perceptions of social injustice. In a series of
paintings dealing with Sacco and Vanzetti, a pair
of Italian-American anarchists who were executed
for murder in 1927, Shahn used the trial to depict
Sacco and Vanzetti as victims of prejudice institu-
tionalized in the system of justice in America.
Like Marsh, Shahn worked from photographs and
manipulated details and techniques to make his
political statement. In the process, he helped to
transform Sacco and Vanzetti themselves into
symbols of the results of political oppression.

During the Depression the Federal government
sponsored a number of projects designed to employ

171

artists and to enhance the spirit of the country. Among them were the Public Works Art Project, the Works Progress Administration's Federal Art Project, the Treasury Relief Art Project, and the Treasury's Section of Painting and Sculpture. The most noteworthy works from these programs were the many murals painted on the walls of public buildings of scenes generally related to the function of the building.

The artist submitted to a committee a sketch and a statement on the medium he would use and received approvals from the committee at various stages of completion of the project; only a few were done without this bureaucratic arrangement. The artists were paid $69.00 to $103.00 per month for a given number of hours of work. The Treasury section murals were, however, done on a competitive basis with the winner of the competition receiving $800.00 or $700.00 to do the mural.

Most of these murals are in a representational style, meant to be viewed by and understood by the average taxpayer; they generally have non-controversial subject matter. In fact, the work done by most of the artists was rather conventional if not conservative. Abstract art was not thought to be in the spirit of democracy in the thirties, but still only for the elite. Indeed, in the easel divisions of many of the projects, radical innovators of later years were conservative representationalists in the 1930's. Jackson Pollock, Mark Rothko, Ad Reinhart, for example, future radicals, were joined by the traditional social realists like John Steuart Curry, Jack Levine, and Marsden Hartley in executing the government's work.

Other divisions of the projects provided work for artists in the fields of sculpture, graphics, design, and photography. Of these, the most

significant was the Index of American Design, and
the photography work done by the Rural Resettlement
Administration, later called the Farm Security
Administration.

Five hundred illustrators produced drawings and
watercolors of American crafts and folk arts at
thirty-two centers across the country, covering
colonial times to the late nineteenth century in
some 17,000 pieces of materials including public
and private collections. It was a thorough,
systematic catalog of typical American folk arts.
Most important was the index treatment of Shaker
folk art which illutrated the diversity of simple
utilitarian Shaker design. A body of research
material supplements the images.

The FSA program resulted in the spectacular
documentation of the American people during the
Depression, showing the poverty, both rural and
urban, which wracked the country. Walker Evans'
documentary of the southeastern part of the
country, as well as West Virginia and Pennsylvania,
captures sharecroppers, their families, and the
remnants of their society. The photographs are
accompanied by a brilliant text by James Agee for
the book Let Us Now Praise Famous Men. Ben Shahn
took up photography in earnest under the influence
of Evans and, with a right angle view-finder that
allowed him to shoot his subjects unaware, docu-
mented the Midwest and, South of Ohio, the
Carolinas, Kentucky, Tennessee, West Virginia, and
Louisiana. Meanwhile, Berenice Abbott covered the
architecture, sculpture, and the people of New York
City.

Because of the Federal arts projects during the
Depression, many artists came to know each other's
work and to exchange information on contents,
techniques, and other ideas about their paintings.
Working, and sometimes living together, fostered a
spirit of competition and experimentation which is

little apparent in the actual works produced by the projects, but was subsequently very important. The development of these ideas was further added to by the many immigrant artist who came to the United States during a period of turmoil in Europe at the beginning of what was to become World War II.

Many of these artists gathered in New York City. In New York, 1939, the Museum of Non-Objective Painting, which was later to become the Solomon R. Guggenheim Museum, opened. The Museum of Modern Art, which had opened ten years earlier showed the work of rising artists on the American scene. By 1940, in fact, New York was recognized as the art capital of the world. Working or exhibiting there were such artists as Piet Mondrian, Max Ernst, Marc Chagall, Ives Tanguy, Andre Masson and Andre Breton, as well as Hans Hofmann, who contributed mightily to a change of direction of American art, and put it on a world class level.

Perhaps the most influential of these immigrant artists was Hans Hofmann. A teacher as well as an artist, Hofmann's message, that was to open artistic vistas, was that art painting was neither a political nor a social tool, that it was self-sufficient, a world unto itself, of a worth of itself, with its own way of communication, its own form, its own strengths and weaknesses. He believed that form itself and color were the essences by painting. He also believed that the source of art was within the artist himself; that the artist contained knowledge innately of form and line, painting's way of communicating. Hofmann believed that intuition, instinct, emotion, and mood projected by the artist through his medium was a way to purify art and make it come alive. Hofmann also preached that each medium had certain qualities which artists had not been completely

174

exploiting. The texture inherent in oil gave that medium a dimension which was lacking in watercolor, for example. In his own work, Hofmann demonstrated many of these theories, exploring the nature of color, the paint itself. From Munich, Hofmann took his ideas to New York, Massachusetts, and California; and he influenced a generation.

Meanwhile surrealist painters, who attempted to project their deep inner selves into their paintings, influenced, on their rise to popularity, native American painters to paint their unconscious without regard to projecting external reality on the canvas. The spontaneous performance of the artist painting, called automatism, sought to project the unconscious without filtering it through layers of unwanted cognition. Non-deliberate, action-forming line and color on the canvas without rational interference was one way to achieve the painting of the unconscious. Essentially, in this mode, artists expected to be able to tap the unconscious to reveal secrets of personality or life that would reveal another entire level of reality and create a deep personal art of expression, abstract from the unconscious.

Resulting paintings depict odd, outrageous, humorous, and sometimes boring images; but not all of it was art, despite the artist's deep belief in Sigmund Freud and Carl Jung and the hope to tap the collective unconscious of all of mankind, and their attempts to stir feelings through mythic forms by timeless and universal messages.

The amalgam of surrealist ideas and the ideas espoused by Hofmann is called abstract expressionism. Many abstract expressionists, such as the Spaniard Miro, however, chose to begin a painting, see what automatism produced, and then apply final aspects, with recourse to their rational levels of consciousness, in an effort to provide structure to the beginning image.

175

In his early works, Jackson Pollock (1912-1956)
painted in that manner, but then changed so that
the spontaneous gestures were not linked to specific
images. Rapid execution of the creative process
became for Pollock the compositional factor; and
the larger the canvas, the better to allow the
artist to play at his work. The process Pollock
used is called action painting, where the art of
painting was as much an art as is the canvas that
is produced by it. The painting then becomes a
record of the artist's activities that produced it.
Beginning by approaching the canvas without pre-
conceived ideas, as in the automatist manner,
Pollock would swirl and dance around it in an
ecstasy of artistic activity, reacting to what he
saw that he was producing very quickly, and also
reacting to his own bodily sensations in the
process. Art for Pollock was a ritual. Pollock,
in fact, in order to keep up with his process of
creation, shunned brush strokes in favor of faster
application by dabbing the paint on the canvas. He
moved from that, by 1953, into putting blotches of
color created by pools of paint on the canvas.
Naturally, the larger the canvas the freer Pollock
was to work out the "myths" of his experience. The
canvas became a field that his psyche played on.
And since the paintings were unplanned, they have
no bounds on the canvas. That is, the painting
seems to end in space only because that happens to
be the place where the canvas ends. There is no
center for the eye to find, no lines radiating;
symmetry is informal if existent at all, and it has
no parts. It is not drawn, since scale is not a
part of its existence.

Because the forms on the canvas seem to be
created by the large physical gestures of the
artist, such painting is called gestural, an
approach used, with differences, by other important
artists, notably William De Kooning (born 1904).
De Kooning, whose initial training took place in
Rotterdam, differs from Pollock in that his work

contains recognizable figures, has an outer edge, a center, and is similar in conception to the Cubist works of years earlier. In his later work, however, the edges disappear, the middle is more amorphous, although the painting a still figurative and is created by the application of seemingly large slashes of paint. These figures, usually women, have no cultural or historical identification, and are thus a mythic presentation, vulgar, earthy, fleshy, all accentuated by the textures of the paint and the choice of colors. Gesture and image are one.

Another important gestural painter, Franz Kline (1910-1962) used wide energetic brush marks of black paint on a white canvas. Many feel that the shape depict skyscrapers, railroads, and highways. His work is in fact non-representational, gesturalist painting. It is difficult not to see things in Kline's work because they are sensitive, yet boldly simple like most modern engineering achievements.

Other artists formulated paintings in a style related to Kline's, by using masses of color to offset unusual line forms. Among the most successful were Adolph Gottlieb, and Clyfford Still.

Gottlieb (1903-1974) used geometric forms and a kind of calligraphy to create opposing forces which can suggest opposing powerful ideas. Still, born in 1904, uses dark colors, against bright or light forms created out of jagged, figures that suggest soaring spirituality and independence. Still's paintings produce an inordinate feeling of mystical tension and release. To many, he is the best of the abstract expressionist for that reason.

The line painting of earlier artists, creating abstract forms, is not the only style in which the abstract expressionists worked. Forsaking lines as

much as possible, which is the heart of gestural painting, other artists chose to feature the color of their work in a pure form, contained in the most mundane of shapes. These artists, called reductive painters, sought to purify their art of non-essential elements to make it achieve a state independent from influence. The most successful of these artists was Mark Rothko, (1903-1970), whose thin paint application during the 50's in rectangular shapes on giant canvas reveals virtually none of the emotion of the artist. Without the irregular edges at the sides of these forms caused by the brush strokes, a viewer would be hard-pressed to discover the behavior of the painter at work. The colors of these figures contain the subtlest of shadings, which make the rectangles seem to shimmer and dissolve, a seeming action which is enhanced by the lack of focus on a center in the painting.

Barnett Newman's (1905-1970) painted figures, while not as purely geometrical as Rothko's, are also enormous, and also dominate the viewer's consciousness with their color as well as their size. In contrast to Rothko's, which feature roughly complementary colors, Newman's feature a single color intensified in a field of the same color. Newman believed his paintings were artifacts of creation itself. Clearly Newman's analytical approach to his work is a denial of the spontaneous process believed in by many abstract expressionists who related to the techniques of automatism in the fashion of Pollock.

In a similar manner, Ad Reinhardt's later painting in the 50's of solid fields of black on canvas are cerebrally planned purifications, highlighted by subtly different tones of black. Similar to Rothko's work in that his paintings are simple, geometric, and of pure paint, Reinhardt's work reduces painting to its simplest aspects -- shape and color.

Later artists, during the 60's, in an effort to expand the scope of the abstract expressionists, stressed more order and planning in their use of color and shape by creating emphatically clearer images, emphasizing sharp lines rather than the blurred lines of the abstract expressionists. Simultaneously, however, the opposite values were being taken up by another group of artists. Because the work of both groups was a development of the ideas and techniques of the abstract expressionists, these painters have been called post-painterly abstractionists.

These painters emphasizing the linear quality of their work, the "hard-edge" painters, focused their attention on the shapes of their designs. Al Held born 1928, painted huge geometrical figures without regard to background color; Ellsworth Kelly, born 1923, put tremendous coloration inside concise geometric shapes. Jack Youngerman, meanwhile, stressed shapes in series.

At one time married to the abstract expressionist Robert Motherwell, Helen Frankenthaler became a leader of the group opposite of the "hard-edge" painters. Frankenthaler followed Hofmann and then Pollock's example by dripping, pouring, and brushing paint on unpressed canvas. The effect is delicate, spontaneous shapes in well-chosen colors.

Morris Louis, directly influenced by Frankenthaler's techniques, poured acrylic paint on unpressed canvas and allowed the colors to soak in and blend lightly into one another, creating translucent color stripes, and eliminating texture altogether. A later group of paintings, done during the 60s, his "unfurled series," finds these ribbons of colors flowing diagonally across the canvas, leaving large untouched areas of the canvas open and free.

Working also with bands of color, Kenneth Noland, born 1924, used chosen shapes of bullseyes,

chevrons and simple parallels around which he
fashioned his colors in the 60's. The blurred
unevenness of line, which bears similarities to
those of Louis and Frankenthaler, were, however,
painted by Noland free-hand with large gobs of
thick pigment. The result is a study of different
colors in a bound, familiar space. Other artists,
from the Washington, D. C. area, further developed
these techniques, such as Gene Davis and Tom
Downing, and together became known as the Wash-
ington Color School.

Despite the fact that abstract expression
occupied the interests of artists and audiences
alike during the middle years of the twentieth
century, there were both artists and audiences
whose interests and attitudes were were almost
completely opposed to the expressionist idea of
working out emotions on the canvas. These artists
stayed within the frame of representationalism, a
representationalism, in fact, which stressed the
representation of objects known to the vast
majority of Americans; some of these objects were
commercial items, others were items in such wide
use as to become cultural icons. Some of these
artist used objects which were widely known but
somehow slightly changed them in the process of
artistic creation. The most prominent of these
artists are Larry Rivers, Robert Rauschenberg, and
Jasper Johns.

Rivers takes subjects from everyday life and
reworks them in his paintings. The most out-
standing example of this technique is Dutch
Masters and Cigars III, (1963). Here he roughly
reproduced a Dutch Masters' cigar box with the
cigars below, and a kind of rough reflection of the
Dutch men at the bottom of the canvas.

In two paintings, Factum I and Factum II,
Rauschenberg, born 1925, first makes a gestural,

seemingly random, painting and then copies it, incorporating identical collage materials. The two paintings together are similar in conception to Rivers' Dutch Masters cigar box, roughly copied as a painting, except that Rauschenberg's known object is his own, just completed, collage, gestural painting. Rauschenberg also used a vast array of collage materials with other gestural paintings and attached pieces of the everyday world to paintings. He called the result "combines." Their total effect is to make these objects disjunct from their ordinary usage and communicate a sense of newness of point of view concerning the values, and the possibilities of associations, that they would have for the viewers. An outstanding example of this idea, which is pretty much recycled from Marcel Duchamp, is Rauschenberg's Monogram (1959). It consists of a stuffed angora goat with a tire wrapped around its midsection, standing on a painted canvas. The viewer is forced to think of a logical connection or rational association between the three objects, and, finding none, is forced to imperfectly apprehend the three objects as unified nevertheless. These works, in their Dadaist, avant-garde conception, bear strong similarities to the work of the avant-garde composer John Cage, who was present at Black Mountain College when Raunschenberg studied there.

Less flamboyant in style than Rauschenberg, but working in the same general field, his friend Jasper Johns utilizes cultural icons, drains items of emotional value by means of repetition, or by odd changes in in perspectives, and thereby forces the viewer to consider anew the formal qualities of line, shape, and color. Johns uses the flag of the United States, targets, and maps, presenting them in multiple images, or gives them unusual texture through the technique of encaustic, suspending pigment in melted wax, or by dripping paint in odd

representational areas of the painting, and by stenciling words to identify or misidentify colors or items in a painting. The most outstanding example of Johns' work is <u>Painted Bronze</u> (1960).

<u>Painted Bronze</u>, is a "statue" of two Ballantine ale <u>cans</u>. They do not represent the products of mass production because they are different sizes; one is a mold, the other the hollow cast of the sculpture which is in the traditional bronze. The viewer is led to three levels of understanding: 1) The apprehension of two common beer cans as found objects of art. 2) The apprehension that the "cans" are not cans but traditional bronze sculptures. 3) That the cans of differing size are not strictly representational sculptures; what they are is something in between the known and purely imagined.

Taking the style of Rauschenberg and Johns a bit farther in the 1960's and 70's was a group of artists centered in New York City who reproduced aspects of American life with the commercial slickness of the advertising media and the comic strips. The style is called Pop Art. Among the most famous artists working in this area are Roy Lichtenstein, Robert Indiana, and Andy Warhol.

Indiana presents as a painting a word such as <u>Love</u> (1972) as if it were a neon sign found on U.S. 1. Lichtenstein's comic book recreations, taken from adventure and romance comics, fit glamorous people with laconic and ironic quotations in the bubble above their heads. His reproductions on a large scale require him to put little dots in his color fields to simulate photoengraving reproductions.

Andy Warhol, the most famous of the group, has depicted famous celebraties ranging from Marilyn Monroe to Mao Tse-Tung and familiar objects

182

faithfully repeated row upon row, such as the canvas of Brillo boxes or Campbell soup cans. Ironically, he rubber stamps his name on the back to simulate mass production. Indeed, he calls his studio, The Factory.

Similarly, a group of artists in the 70's, attempting to recreate the fidelity of the photographic camera, paint common objects with such a high degree of precision as to be called the "new realists". Ralph Goings' Olympic Truck is an example of the type; Red Grooms' Loft On 26th Street might be considered another. On the other hand, other artists have tried to reproduce the styles of other eras, within a modern context, such as Philip Pearlstein with male and female nudes in Red and Purple Drape. It emphasizes a distinctly studio level of personal vision because the subject is lit by electric lights. Alfred Leslie, whose The Killing of Frank O'Hara, is done in the 17th century Italian style is another example. O'Hara, curator of the Museum of Modern Art, and a poet, was killed on the beach by a car at Fire Island in 1966. Leslie's handling of the paint here is much simpler than that of 17th century artists. There is no massive glazing, a major technique of the 17th century.

Abstract expressionism has never entirely left the art scene, but acquired a new name and a more sophisticated technique, called formalism. Formalistic paintings seek to create a world without reference to any other, to make the flatness of the canvas manifest itself as a legitimate world, in the same way Noland, Louis, and Frankenthaler conceived of the canvas. Frank Stella's Arundel Castle, a formalist painting, for instance, consists of half rectangles contained within each other in repetition.

In general, the 60's and 70's was a period in which painting shifted from the radically

subjective action painting to quieter, more intellectually controlled forms featuring apparent objectivity. Pop Art's repetition, the use of color for its own sake, and the production of groups of completely recognizable patterns resulted in art works dominated by predictability, and above all by order.

Some of the older artists such as Barnett Newman and Mark Rothko had made paintings in an earlier time that were composed structural shapes -- arrows, lines, squares; and then new artists in revolt against the free form of the Abstract Expressionists, joined the AE's color with preconceived shapes, as in works such as Kenneth Noland's targets and chevrons, and Morris Louis' dripped stripes. A later group, still emphasizing color, and following the older constructivist idea of reducing painting shapes to basic structural patterns, featured fabrication in their paintings. The resultant optical painting relies on perceptual dynamics to produce the image and a related after image among similiarly hued colors in a patterned field. Systemic painting, in the world of Johns and Rauschenberg, a second category, blurs the line dividing sculpture and printing and is similar to the construction and assemblage kind of sculpture, and also bears similarities to the repetitive qualities of Pop Art. Using simplified forms, usually perfectly geometrical, in serial repetition, these artists brought to painting the same elements of boredom as a thematic unity that was present in film, such as The Graduate, dance and music, during the period. The art is non-expressive and in-expressive, bound and determined. In paintings which were figured, the figures themselves are disembodied, becoming distant icons of the subjects that they supposedly represent. Frank Stella's work is of this type, as is that of Al Held and Ellsworth Kelly. They all feature shapes which have no meaning, which are bulky, unappealing in line or tone of color.

The total breakdown of form and format in painting in the 60's, and their substitution by non-form and non-format, undermined, temporarily, the art of painting itself; and it led, inevitably, to a dead end. Art cannot develop without structure. The total freedom to express boredom with society, or protest against technology, developed paintings, which, today, are curiosity pieces of a bereft era. The barrenness of this conception was all too apparent during a five man show at the Corcoran Gallery in Washington, D. C., in 1979 which featured the work of five of these artists -- Rauschenberg, Johns, Ellsworth Kelly, Roy Lichtenstein and William De Kooning.

While not popular during the period of the 60's, other painters, working in traditional and representative modes, sharpened their skills and techniques. During the 70's the enthusiasm and Americanness of the Abstract Expressionists, and those who painted in stylistic offshoots of the AE's in later years, captured mass audiences. As market opened up, so did the syles of painting.

Fields, urban landscapes, toys, fences, cars, all became the subjects of representational paintings, sometimes rendered in a style which was similar to that of the French Impressionists of a century earlier. Indefinite in line and shape, highly evocative of a sentimental mood, sometimes styled as vividly representational as that of a photo snapshot, the art showed the ability of the artist to recreate manually the effect of the camera. One artist working in this style is Fairfield Porter. All of this set well with viewers who had been through the radicalism of the preceding decade, and of course with those new to painting. It offered a solid, permanent vision of known object in a straight forward way -- no irony, no jokes on the eye -- art on a middle ground of creativity and prescription -- art relying on the tradition of art, and the traditions of Americana.

185

One of the hottest types of painting, and of sculpture, was Western art. Many of its practitioners began their careers as abstractionists, then tired of exploring themselves and their emotions in an ego-centered art form, and switched to portraits of moments of history, of Indians, and cowboys on the open range. Beginning in popularity in the West, among new collectors and museums, the movement flowed East, itself a break from the tradition of American art developing on the East Coast and flowing westward to trendy California. The late 1960's, with its domestic chaos, was the period when the movement started; but it did not flower until the late 70's, a period of international chaos, symbolized by the disruptions of energy which altered the lifestyles of most Americans. The subjects of a vanishing West, of another, simpler, independent age, was its lure. Its practitioners, like good business or labor unions, organized themselves into the Cowboy Artists of America, in order to promote themselves and their work. The nostalgia of their subject matter is clearly controlled by a fine business sense.

Joe Beedler, an illustrator and real cowboy, (and part Indian), Charles Dye, a Colorado painter, and John Hampton, an illustrator of the Red Ryder comic strip, were the founders of the group. Its annual exhibition sells $756,000 worth of art to collectors dressed in gowns and tuxedoes who will hang the paintings in banks, car dealerships and medical offices. The significance is that people of talent, forced by economic pressures to consider painting a sidelight previously, have returned to the art, and in an era of inflation which makes paintings a good tax shelter, have filled a psychological or sociological demand in the minds of audiences.

Their paintings, however, are not just business chits. They explore the American experience from a

186

1970's perspective. They tend to emphasize
loneliness, deprivation, and the necessity of
self-reliance, as exemplified in Gary Niblett's
Bitter Cold, three men on the snowy prairie huddled
by a campfire, horses, a wagon, and range riders in
the background against a harsh and unremitting sky.
To some, Bitter Cold is a domestic vision of
America's position in the international society,
whose central conception of Earth as a global
village puts America into forced interpendence with
less stable and hostile countries. Self-reliance
in that world is a must, and it is figured in the
self-reliance of these cowboys and their place in
American history. Bitter Cold is not an abstrac-
tion of feeling or a mind game; it is presentation
of natural reality, of people doing what they have
to do to survive.

At the same time, an urban genre has re-arisen,
although different from the stylistics of realism
during the 20's and 30's. Now the emphasis is not
on the down and out types haunting street corners
and all-night cafes, as in Hopper's painting, but
rather simply of people going about their shopping,
parking, driving and business downtown, in re-
surgent inner cities, newly alive with the return
of the moneyed middle class. Typically painted
using the arresting color schemes of the old AE
style, these paintings are at once lyrical and
hard. Stop lights glare on wet black asphalt;
dented cars crunch into parking spaces, their
drivers with necks craning, judging the distance to
the bumper of the next car. The faces are alive,
not with joy or fear, not mummified by boredom, but
alive with meeting the challenge of getting the job
done, getting the cars parked, getting on. In fact,
traffic getting on is the subject of many of these
paintings. They are being painted in all styles,
in all areas, and all make a statement about life
and times and the reality of the late 70's.

187

Typical of this style is the work of the little
known, but well-received young artist Michael
Francis. <u>Washington Circle</u> shows a line of cars
heading home to the suburbs, the low Western sun
casting the scene in an orange glow of the day's
finish. Patience, life, and bearing with the system
are what the painting says. At the same time, the
scene is rendered with the broad brush strokes of
the action painters; the purples and oranges pat-
terned into rough geometrical shapes of the AEs,
rendered in the depiction of the cars, the street
and the sun itself. The painting combines realism,
and expressionism into a new form of distinctly
American impressionism whose subject is the reality
and permanence of American culture.

Recommended Reading

Arnason, H. H. History of Modern Art: Painting
and Architecture. Englewood Cliffs, N.J.:
Prentice-Hall and Co., 1977.

Cahill, Holger. American Painting and Sculpture
1862-1932. New York: Arno Press, 1932.

Cahill, Holger, and Alfred Barr. Art in America in
Modern Times. New York: Arno Press, 1934.

Cleaver, Dale, and John Eddins. Art and Music: An
Introduction. New York: Harcourt Brace
Jovanovich, Inc., 1977.

Faulkner, Ray. Art Today. New York: Harcourt
Brace Jovanovich, Inc., 1974.

Glubok, Shirley. Art of America in the Early
Twentieth Century. New York: Macmillan, 1974.

Gottlieb, Carla. Beyond Modern Art. New York: E.
P. Dutton, 1976.

Horst, Louis, and Carroll Russell. Modern Dance
Forms in Relation to the Other Modern Arts.

Hunter, Sam, and John Jacobus. American Art of the
Twentieth Century. Englewood Cliffs, N.J.:
Prentice-Hall, 1974.

Janson, H. W., and Joseph Kerman. History of Art
and Music. New York: Prentice-Hall, 1969.

Kleinbauer, W. E. Modern Perspectives in Western
Art History: An Anthology of 20th Century
Writings on the Visual Arts. New York: Holt,
Rinehart, and Winston, Inc., 1971.

Lucie-Smith, Edward. Late Modern: The Visual Art
 Since 1945. New York: Oxford University
 Press, Inc., 1975.

McLanahan, Richard. Art in America. New York:
 Harcourt Brace Jovanovich, Inc., 1973.

Mendelowitz, Daniel. A History of American Art.
 New York: Holt, Rinehart, and Winston, Inc.,
 1970.

Read, Herbert Edward. A Concise History of Modern
 Painting. New York: Preager Publishers, 1959.

Ritchie, Andrew. Abstract Painting and Sculpture
 In America. New York: Arno Press, 1951.

Rosenblum, Robert. Cubism and Twentieth Century
 Art. New York: Abrams, 1961.

Rubin, William Stanley. Dada Surrealism and Their
 Heritage. New York: Museum of Modern Art.,
 1968.

Rublowsky, John. Pop Art. New York: Basic Books,
 1965.

Soby, James. Modern Art and the Past. Norman:
 University of Oklahoma Press, 1957.

Taylor, Joshua Charles. The Fine Arts in America.
 Chicago: Chicago University of Chicago Press,
 1979.

Tighe, Mary Ann, and Elizabeth E. Lang. Art
 America. New York: McGraw Hill Book Co.,
 1978.

Werner, Hofmann. Turning Points in Twentieth Art:
 1890-1917.

190

Afterword

The diversity of technique and subject matter within the art forms reviewed here is amazing. It shows American artists of the twentieth century willing to explore deeply held personal feelings as well as more widely held national beliefs with every means at their disposal. Currently, in the 1980's American arts are in a period of integration of the newer techniques into generally traditional forms, specifically the integration of expressionistic techniques within realistic formats. This trend is most notable in painting and theater and music. It is not a new trend in motion pictures, perhaps because the development of expressionism and realism and the initial developments of cinematic forms all took place during the same period, the twenties and thirties. Dance has always been concerned, by its own nature, with expressionism; so it, too, like motion pictures, is not newly joining the expressionism and realism at the current time.

The temptation is always present to point to the particular works of art which are most important in the development of the arts of twentieth century America. While many strong candidates can be advanced as being the most influential among the thousands of significant art pieces of the twentieth century in America, it seems that there are a few which stand out. These art works not only have inherent and overwhelming aesthetic value, but also are important historically within the development of the art form. They are also historically important to the identity of twentieth century America.

In dance, Jerome Robbins' Nutcracker has become an icon of the Christmas season. Alvin Ailey's Revelations presents a dramatic image of the black

191

experience. Martha Graham's Lamentations is an
expressive picture of the universal suffering and
grief with which all humans can identify.

In orchestral music, Charles Ives' Third
Symphony beautifully shows that the boundaries of
the tonal scale can be laid aside, and art will
still come forth. Aaron Copland's Appalachian
Spring, on the other hand, shows tonalism to still
be a valid and expressive medium of America's ways.
In popular music, the leadership of Benny Goodman,
and Charlie Christian, as well as John Coltrane
gave America its only self-created art form --
jazz. Chuck Berry's work gave rock 'n' roll its
distinctive style. Since Berry , rock has gone on
to be a major aspect of American lives, and a
tremendous influence on the lives of people in
other countries as well played in the style of
Jimi Hendrix.

In drama, Eugene O'Neill, typically in plays
in which a character personifies O'Neill himself,
brought realism and expressionism together in
perfect synthesis. Winterset by Maxwell Anderson
and Death of a Salesman by Arthur Miller are
political and social dramas which allowed audiences
to see the real underside of twentieth century
America. Show Boat opened the way for social
issues in musicals and also was the show which gave
the medium its structure. Oklahoma! gave America
great music.

In movies, Griffith's The Birth of a Nation
took that art form to a level of high development
very early in its history, and was an aesthetic and
social statement simultaneously. Citizen Kane by
Orson Welles used the cinematic tradition as a
source of dramatic tension and beauty. And Francis
Ford Coppola's Godfather realistically portray
America as it is with a high level of technical
virtue.

In architecture, Frank Lloyd Wright's
Falling Water typifies the spirit of the inter-

national style as adopted to domestic architecture.
The office buildings of Philip Johnson, likewise,
are paradigms of that style on a grander scale.
The Seagram Building by Johnson and Mies van der
Rohe is the earliest and best developed example.

In sculpture, the work of David Smith,
particularly his Agricola constructions bring
abstraction to aesthetically pleasing shapes.
Calder's mobiles, particularly the one hanging in
the East Building of the National Gallery of Art in
Washington, D.C., and Oldenburg's Lipstick on
Caterpillar Tracks, even after its removal from
Yale, gave sculpture new emotion -- the emotions of
serene humor, and satiric humor respectively.
Robert Smithson's Spiral Jetty expanded sculpture
to gargantuan scale and let people see the beauty
of their own land.

In painting, the French-born Marcel Duchamp's
Nude Descending a Staircase influenced American
painters to develop abstract expressionism. In
this style the works of Clyfford Still are for
many, the most fascinating. The process of
integrating expressionism with that of realism will
lead to remarkable art in the future.

All of these works and others, have reflected
and determined America's view of itself in its arts
in this century.

INDEX

A

197

198

201

Hawkins, Coleman, 41
Hawks, Howard, 100, 101, 107
Hayden, Melissa, 9
Hayes, Helen, 62
Hay's Office, 107, 112
Hecht, Ben, 107
Held, Al, 179, 184
Held, Anna, 85
Hellman, Lillian, 62, 79
Hello Dolly!, 90
Hemingway, 21, 65
Hendrix, Jimi, 41, 43, 44, 47, 50, 51, 52, 192
Henri, Robert, 160, 161, 167, 168
Henry VIII, 65
Hepburn, Katharine, 78
Herbert, Victor, 86, 87
Here Come The Clowns, 62
"Here Comes The Night," 52
Herne, James A., 74
Heyward, Dubose, 61
Hickey, 63
Higgins, Professor Henry, 90
High Noon, 103, 115
High Tor, 65
Highland Park, Illinois, 131
Hirshhorn Museum and Sculpture Garden, 134
Hitchcock, Alfred, 110, 111
Hoffman, Dustin, 113
Hofmann, Hans, 174, 175, 179
Holabird and Roche, 125
Holly, Buddy, 41, 47
Hollywood, 100, 102, 104, 114
Home Insurance Building, 125
Homer, 70
Hopkins, Arthur, 62, 77
Hopkins, Lightnin', 48
Hopper, Dennis, 105
Hopper, Edward, 168
Houdini, Harry, 87
House of Usher, The, 110
Houseman, John, 78
Howard, Sidney, 61, 65, 76, 78
Hoyt, Charles, 85
Hud, 116
Humphrey, Doris, 16
Hunchback of Notre Dame, The, 109

Husbandman, 19
Hustle, 51
Huston, John, 103

I

I Saw The Figure 5 In Gold, 168
Ibsen, Henrik, 60, 74, 76
Ice Cream Cone, 156
Iceman Cometh, The, 63
Illinois Institute of Technology, 128
"I'm Just Wild About Harry," 87
Imperial Hotel, 131
"In The Inn," 21
"In The Night," 21
Index of American Design, 173
India, 134
Indian, 116, 137, 186
"Indian Love Call," 88
Indiana, Robert, 182
Industrial Revolution, 37, 122
Inge, William, 79
Ingres, 163
Interludes, 3
International Exhibition of Modern Art, 162, 163
International Ladies Garment Workers Union, 88
International Style, 127
Intolerance, 15, 198
Ionesco, Eugene, 72
Iowa, 170
Irene, 87
Irfa, 100
Irish, 85
Irving, Washington, 107
Italian American, 171
"Italian Street Song," 86
Italy, 104
Ives, Charles, 20, 27, 28, 31, 192
Ivesiana, 20, 21, 22

J

Jacobs House, 132
Jagger, Mick, 49

208

Lunts, 62

<center>M</center>

Mabou Mimes, 82
Macbeth Gallery, 161
Mac Donald, Jeannette, 101
Mac Donald Wright, Stanton, 163, 166
Mac Dowell, Edward, 27
Mac Gowan, Kenneth, 62, 76
Madison Wisconsin, 132
Mafia, 105
Mahler, Gustav, 31
Maillol, Aristide, 146, 147, 163, 164
Makarova, Natalia, 10
Mamas and the Papas, 49
Man of La Mancha, 90
Mamet, David, 82
Mandrell, Barbara, 55
Manet, 163, 164
Manhattan, 113
Mantle, Burns, 62
Mao Tse-Tung, 182
March of the Vampire, 110
March of Time, 102
Marco Millions, 61
Margaret Fleming, 74
Mark Taper Forum, 83
Married Student Housing, 133
Marsh, Reginald, 171
Marshall Field Building, 123
Martha's Vineyard, 169
Marx Brothers, 99, 112
Mary, 87
Mashed Potatoes, 47
Mason, Uncle Dave, 54
Massachusetts, 175
Masses, The, 161
Masson, Andre, 174
Matisse, 163, 164
Maynard, Ken, 105
McCarthy, 70, 103
Mc Clanahan, Preston, 152
McClintic, Guthrie, 62
McGee, Sam and Kirk, 54

Rousseau, 163, 164, 166
Runnin' Wild, 87
Running Fence, 151
Rural Resettlement Administration, 173
Russell, Lillian, 85
Russell, Morgan, 163, 166
Russell, Roy, 112
Russia, 61, 64
Russian, 80
Ruth, Babe, 99
Rydell, Bobby, 47
Ryskind, Morris, 88

S

Saarinen Eero, 133, 134
Sacco-Vanzetti, 65
Sacco and Vanzetti, 171
Sackler, Howard, 73
Safety Last, 111
St. Denis, Ruth, 3, 14, 15
St. Gaudens, August, 144
St. John's Abbey, 128
St. Louis, 176, 134
Salem, 70
Sally, 87
Sally, Irene, and Mary, 87
Salt Lake City, Utah, 158
Salvation Army, 75
Salvation Nell, 74
Sandbox, The, 72
San Diego, 130
Sandusky, Ohio, 15
San Francisco, 50
"Satisfaction," 49
Saudi Arabia, 139
Scandals, 88
Scarface, 107
Schindler, Rudolph, 133
Schlesinger and Meyer Department Store, 124
Schoenberg, Arnold, 10, 31, 32
Schwantner, Joseph, 35, 36
Schwitters, Kurt, 150
Scorcese, Martin, 105
Scriabin, 31
Sculpture Series A, 151

The author was born in Ft. Myers, Florida, but was brought up in Clifton, New Jersey, and graduated from Montclair State College, just outside of New York City. He then went on to receive an M.A. and Ph.D. degrees from the Catholic University of America in Washington, D. C. For the past eight years he has been the Director of Arts and Humanities at Charles County Community College near Washington, D. C. He has contributed to helping the Community College to a position of leadership in the development of regional cultural programs. This book grew out of a course he has taught for the past three years on the arts in America, and which is part of the regional studies programs at the school.

In addition to numerous articles on the teach-of English composition, Dr. Klink has also published Maxwell Anderson and S. N. Behrman: A Reference Guide and S. N. Behrman: The Major Plays, as well as co-authored works on colonial agriculture.